D0176756

SSF

Praise for Laura Crum's

Moonblind

"Moonblind opens a reader's eyes—to relationships, to the complicated inner life of a woman in transition, to the role of four-legged creatures in our lives. Sometimes a mystery novel is more than simply Whodunit; in Laura Crum's latest, the Why of the act is equally compelling, and the story's Where becomes more of a character than merely its setting."

—Laurie R. King, *New York Times* bestselling mystery author

"Crum's diverting ninth equestrian mystery...[is a] credible look at the high-stakes world of horse breeding and training."

—*Publishers Weekly*

"The beauty of the natural surroundings is brought palpably to the reader by Crum's evocative writing, and she provides glimpses into the fascinating world of racehorses."

—*Mystery Morgue*

"Crum allows the suspense of the story to build slowly.... The concluding scenes in t̶ vide a shocking d

"With over thr terfully blends

"Moonblind will ful sense of pl its focus. Of co enjoys stories read.'"

S.S.F. Public Library
West Orange
840 West Orange Ave.
South San Francisco, CA 94080

MAR 2008

Chasing Cans

The Gail McCarthy Mystery Series
by Laura Crum

Cutter
Hoofprints
Roughstock
Roped
Slickrock
Breakaway
Hayburner
Forged
Moonblind
Chasing Cans

Chasing Cans

A GAIL McCARTHY MYSTERY

Laura Crum

McKinleyville / Palo Alto // 2008
John Daniel & Company / Perseverance Press

This is a work of fiction. Characters, places, and events are the product of the author's imagination or are used fictitiously. Any resemblance to real people, companies, institutions, organizations, or incidents is entirely coincidental.

Copyright © 2008 by Laura Crum
All rights reserved
Printed in the United States of America

A PERSEVERANCE PRESS BOOK
Published by John Daniel & Company
A division of Daniel & Daniel, Publishers, Inc.
Post Office Box 2790
McKinleyville, California 95519
www.danielpublishing.com/perseverance

Distributed by SCB Distributors (800) 729-6423

Book design by Eric Larson, Studio E Books, Santa Barbara, www.studio-e-books.com
Cover design and illustration by Peter Thorpe

10 9 8 7 6 5 4 3 2 1

LIBRARY OF CONGRESS CATALOGING-IN-PUBLICATION DATA
 Crum, Laura.
 Chasing cans : a Gail McCarthy mystery / Laura Crum.
 p. cm.
 ISBN-13: 978-1-880284-94-0 (pbk. : alk. paper)
 ISBN-10: 1-880284-94-4 (pbk. : alk. paper)
 1. McCarthy, Gail (Fictitious character)—Fiction. 2. Women veterinarians—Fiction.
3. Racehorse trainers—Crimes against—Fiction. 4. Santa Cruz County (Calif.)—Fiction.
I. Title.
 PS3553.R76C47 2008
 813'.54—dc22
 2007032300

To Zak, with love,
(and thanks for his patience while I wrote),
and Toby, his pony,
Baxter and Tiger, his cats,
and Fergie and Jojo, his dogs.

With thanks and love also to my very dear husband, Andy,
who makes these books possible.

My gratitude to those who helped with this project:
Craig Evans, DVM
Deputy Chief Patty Sapone (SCPD)
Meredith Phillips (editor)
Peter Thorpe (artwork)
Gretchen Tom (typing)
Wally Evans and Brian Peters (wranglers)

And finally, thanks to Plumber, Gunner, Danny, Twister,
Burt, ET, Rebby, and Smoky, and in memory of
Pistol and Flanigan.

AUTHOR'S NOTE

Santa Cruz County is a real place and the climate and scenery are much as described in this book. The human characters are completely imaginary and are not meant to resemble anyone, living or dead. The animal characters, however, are drawn from my life. To learn more about this mystery series, go to www.lauracrum.com.

Prologue

WOMAN ON A HORSE. Long blond hair flying, mane and tail flying, horse and rider suspended in one wide galloping stride, headed for the first barrel. In another moment, this female centaur will round the first turn of the cloverleaf pattern; on the bottom of the black-and-white photo a brief notation gives the horse's name—"Highball"—and "First Place, Salinas Rodeo, 1979"; one can conclude that the run was as good as it appears in the faded photographic print.

The face of this rider is, of course, familiar; I am certain that I have never seen the horse. Were it not for the circumstances, the picture would be relatively meaningless, merely a good shot of a barrel racing run. But now I stare, mesmerized, looking for a clue that would bring this flying horsewoman to life, make it clear who she really is. So my eyes search the framed photo, checking details—clothes, tack, the quirt in the woman's clenched teeth, the shape of the horse's blaze, looking for something, anything—what, I am not sure.

I am hunting for an answer, racing for a solution, even as the woman in the photo is driving toward the finish line, riding hard to win. In this moment we are here, face to face as it were, intent on our goals—for all the good they may ultimately do us. Chasing cans.

Chapter 1

LINDEE STONE WAS ONE TOUGH LADY. I had reason to know; she'd been my veterinary client for many years and was currently my next-door neighbor. None of which had made me the least bit fond of her. For my money, Lindee was a nasty piece of work, albeit a good-looking, blond version of such.

This particular June afternoon, I was nursing my year-old baby and contemplating the hours ahead with a calm and equable mind, when Lindee Stone called me on the phone and shifted my tranquil mood into outright hostility in a few short sentences. Her voice was unmistakable—low, a little hoarse, just a hint of a southwestern twang. "Am I speakin' to Gail McCarthy?"

"You are. Who's this?" I rebutted, although I was quite sure I knew.

"This is your neighbor, Lindee. I just thought I ought to let you know that you'll be needing to move your two horses out of Joanie's field. I leased it."

"What?" I was so startled I jerked upright, causing Mac to lose his latch on my nipple. Since he now had teeth, this was more than a little painful. I tried to muffle my "Ow" through clenched teeth as I let Mac get a good hold and demanded, "What are you talking about? Joanie leased that field to me."

Joan Grant was another neighbor, whose property lay to the west of both mine and Lindee's. Two of my geldings, Twister and Danny, had been living in Joanie's ten-acre pasture for over a year, and Joanie had always seemed happy with the arrangement.

"Not anymore, I'm afraid." Lindee sounded smug. "As of this

morning, that field is leased to me. And I'll have to ask you to get those horses off pronto. I'll be turning some mares out there right away."

"You've got to be kidding. Joanie never said anything to me."

"Call her and ask her," Lindee snapped.

"I will," I said just as sharply.

"And see that you get those horses out of there. I plan to turn the mares out in a couple of days." Click.

I stared at the receiver in my hand, seething with fury, frustration, and confusion. Sensing something, Mac quit nursing and looked up into my face.

Clear, gray-blue, otherworldly, my baby's eyes rested on mine in a mildly questioning way. I took a deep breath. Just as I had on many other occasions in the year since I'd become a mother, I reminded myself to keep my priorities straight. Priority number one was taking care of Mac.

I let my breath out, slowly. Consciously relaxed my clenched jaw. Smiled at my little boy.

"Hey, baby," I said softly. "Hey, Mac."

His answering smile came quietly and sweetly, and after a moment's further scrutiny of my face, he latched on again, apparently convinced that things were all right after all.

Not me. Despite my now outwardly calm demeanor, my mind was racing, trying to solve this new problem that had been thrust upon me by my obnoxious neighbor. Why in the world would Joanie boot my horses out of her field in favor of Lindee's mares? As far as I knew, Joanie didn't like Lindee any better than I did.

Nothing for it but to call Joanie and find out. I watched Mac suck busily and felt the powerful pull that seemed to come from the core of me, certainly from somewhere deeper and more central than a mere breast. How did he do that, I wondered, not for the first time. It truly felt, literally as well as figuratively, as if he were tugging at my heartstrings.

Resolving to let him finish nursing before I engaged in another

upsetting phone call, I stared out my south-facing windows at the vegetable garden fence. June's lush profusion glowed at every point, from the cascading showers of apricot roses, through the pinks and purples of sweet peas, to the flames of nasturtiums, all clambering and scrambling together on the weathered gray-brown grapestake fence. Within the fence, vegetable beds showed dark brown earth marked with neat rows of carrots, onions, peppers, radishes, and basil; mounds of zucchini and crookneck squash; a bamboo tepee was draped in twining pole beans; all courtesy of my husband, Blue. I was grateful that he'd had the energy and desire to put in a vegetable garden this year; I certainly hadn't.

I loved looking at it, though. Just as I loved looking at the much wilder hillside beyond it, where the native brush mingled with meadow grass and some flowering plants that I'd introduced. Those few that had survived, that is. The wild garden was a tough place and competition was keen. For every successfully vivid verbena flower spangling the grass, there were at least a dozen casualties. But the bright purple verbena mingled happily with the golden orange California poppies and the pink-and-white fleabane daisy, and all of them ran riotously through the tall grasses in a profusion of color and movement.

The wild oats were just turning from green to silvery gold, in the way of coastal California summers, along with the native rattlesnake grass, thickly hung with its papery fairy lanterns that rustled in every breeze. The meadow formed a shifting, flickering foreground to the rich ascending shapes and shades of the brushy plants clothing the hillside beyond. Live oak, elderberry, monkey flower, wild lilac, coffeeberry, and greasewood, to name only a few of the main players, provided a rich habitat for the native fauna, and my garden was as lively with animals as it was with plants. I loved this life and movement, this mixing of wild and cultivated, despite the inevitable conflicts, i.e. bobcat versus chickens. I wouldn't have traded my few acres here in the brushy coastal hills by California's Monterey Bay for any fancy piece of manicured real

estate anywhere in the world. I only wished I owned Joanie Grant's ten-acre pasture, too.

Damn. Things had been just fine until that serpent in Paradise, that insufferable Lindee Stone, had moved in next door a year ago. Suddenly the neighboring property, a mere two and a half acres just like my own, had become home to a training barn and over forty horses, with the inevitable coming and going of all those clients, owners, and boarders with their trucks and trailers.

Don't get me wrong. I have horses; I love horses. I'm a horse vet by trade. But even I became rapidly disenchanted with the reality of a large training barn next door. At least this training barn.

Lindee Stone trained barrel racing horses; she also bred and raised registered paints, standing a stallion and keeping at least half a dozen brood mares. As far as I could tell, she boarded horses and traded horses and pursued just about any deal where it was possible to make money on a horse. Ethical or not.

Rumors had always abounded about Lindee. That she had, on numerous occasions, passed horses off as sound that were running on major painkillers, that she had doctored papers to make horses look younger than they were, and sold horses with papers that were not their own in order to make them appear to be valuable when they were not... The list went on and on. It was said that she had left her last training establishment after screwing the owner out of many months of rent. Unfortunately I had reason to know that she'd actually bought the place next door to me, so it didn't seem likely that she'd be leaving any time soon.

Despite her less than unblemished reputation, Lindee Stone still seemed to have a large following, probably because she won. She won at a very high level, competing at numerous rodeos, often successfully. In effect, she could get the job done. And so people came to her for training and lessons, though they often didn't stay with her long.

All this made for a great deal of traffic, noise, and just general equine and human population on the property that bordered my

south fence. The one consolation I'd had was that the whole shindig wasn't visible from my house; oak trees and brush screened it out nicely.

Staring out my window, I frowned in the direction of Lindee's home and horse training operation, feeling Mac's pull on my breast even as I felt the equal and opposite pull—to be up and doing, to take some action, any action, to combat this new foe.

I sighed. I did not jump up, as I longed to do; I did not startle my baby, who was nursing peacefully off to sleep. I held still, taking deep breaths, reminding myself to keep my priorities straight. Priority number one was taking care of Mac. My mantra.

That I honestly believed this did not always make it easy to live by, as proponents of various religious faiths can attest. It had not been easy to tell the senior partner in my veterinary firm that I wasn't sure when I was coming back to work, and when I did, I would come back part-time only. It had not been his expectation, nor had it been mine. I had expected to take six months to a year off to have my baby and then be back at it. Little did I know.

Motherhood had turned out to be everything I expected and more, a whole lot more. Taking care of Mac, being present for Mac, being there to nurture him and raise him had become by far the most important thing in the world to me. Somehow I had, prior to his birth, underestimated the power of this feeling and its far-reaching implications.

And now I struggled once again with the inevitable conflict between this overwhelming drive to mother versus my own wish, neglected but not forgotten, to continue being the assertive, professional woman I was used to being. Gail McCarthy the horse vet, that was me. Independent, strong-minded, competent, in charge—these were the words that came to mind. Not tranquil, maternal, nurturing, patient—the virtues that went with mamahood. And yet, here I was.

Here I was, all right, struggling with the need to actively sort out this situation, to trot on down and confront the despicable

Lindee Stone, and faced with a trusting child whose eyelashes fluttered gently over his closing eyes as he drifted, his gaze still following my face. My baby. My baby who needed his mama—present and loving. Not to mention tranquil and holding still, not dashing off to confront someone. Damn.

I sighed again. Reminded myself I was doing what I really wanted to do. Wondered why being a mother frequently seemed such a difficult task. Was following one's deepest desire always and inevitably one's most difficult challenge?

Mac's eyes were closed now. I knew better than to move. One short year of motherhood had driven home the lesson in no uncertain terms: Let the baby fall completely asleep before you try to move him. And even then, don't count on it working.

I watched the sweet, sleeping face, my heart softening despite my revved-up mind. The perfect, almost translucent skin, the delicate bow of the lips, the soft waves of fawn-colored hair… Mac was beautiful. Of course, all mothers think this, I reminded myself; only in my case, it was really true. Right.

I sat, feeling the warm weight of my baby resting across my lap and arms. This was my life; this was what I was here to do. And what, I wondered, was I going to say to Joanie Grant?

That I needed her pasture? That Twister and Danny, my two horses with major medical problems, weren't sound enough to ride so I couldn't exercise them, let alone I didn't have the time. That they would be terminally bored locked up in corrals all day every day, even big corrals like mine. What was I supposed to do—beg?

I really did not relish making this phone call. Still, there didn't seem to be much choice. Gingerly I shifted Mac. He didn't flinch, he didn't twitch, his eyelids didn't even flicker. By my reckoning, he had moved from REM sleep to deep sleep and could now be moved. Amazing the way all these minute details of motherhood came perfectly naturally to me now, when a little over a year ago I wouldn't have had a clue about any of this. Instinct had its place, also a lot of reading. The one subject I was interested in these days was child rearing.

Carefully, I stood up and carried Mac to the co-sleeper bed that stood next to my own bed. Mac didn't actually sleep in it much; he preferred to be cuddled up by my side, but it was handy as a safe spot to put him for naps, especially when I needed to be doing something.

Once he was settled, still sleeping, I picked up the remote phone and walked back out in the other room. Reluctantly, I dialed Joanie Grant's number.

As I listened to the mechanical ringing tone and waited, I pictured Joanie Grant. A retired schoolteacher, widowed and living alone, Joanie was in her seventies, and still a dynamic, lively personality. We'd always gotten along well, and shared an interest in horses, which had helped the bond between us grow. Joanie had owned horses all her life; when I first started working as a veterinarian, ten years ago, her old mare, Cinnamon, had been in her thirties, enjoying a happy retirement in Joanie's pasture. Since then, Cinnamon had passed on, and last year Joanie had been glad to lease the now empty pasture to me.

At seventy-five, she'd explained, she didn't want to buy another horse, but she still loved horses, loved to see them grazing in the field in front of her house, loved to go out and socialize with them, stroking their noses and getting to know them. My two geldings, Danny and Twister, were very receptive to this, and had quickly learned to amble over to the fence whenever Joanie appeared. She often brought them an apple or a carrot and had steadily grown fonder of them, reporting back to me on individual personality quirks she'd noticed and letting me know when one or the other looked a little "off."

It had seemed an ideal arrangement. Though in theory the field was "leased" to me, Joanie charged me no rent. I took care of all chores, made sure the horses had adequate feed and water, was responsible for veterinary care and regular visits from the farrier, and everybody seemed happy, horses included.

Until now. Even though Joanie and I had several times commiserated over the misfortune of having Lindee Stone and her entourage

right next door, apparently something had convinced the woman to boot my horses out in favor of Lindee's. Money, maybe? It didn't seem likely, given what I knew of Joanie, but all the same, I now wished that I was in possession of a multi-year signed lease and was paying some nominal fee.

"Hello?" Joan Grant's voice sounded older than I remembered.

"Hi, Joanie. It's Gail." I tried not to let the gamut of emotions I was feeling show in my voice.

"Oh, Gail. Good. Or I mean it's not good, it's terrible. But I do need to talk to you."

"Lindee just called... to tell me you leased your field to her," I said, I hoped calmly and evenly.

"That..." Joanie hesitated. "That bitch. I wouldn't normally use that word, Gail, you know that, but that woman deserves it."

"What happened?"

"Well, you should know, she's been after me for a while to lease this field to her. She's got some broodmares she wants to turn out, apparently. I always told her no, that I was happy having your two horses here and that was enough. And to tell you the truth, I wouldn't have leased the field to her if it was empty. I don't want anything to do with her; you know her reputation as well as I do."

"Uh-huh," I said.

"Then, this morning, she called me up, and told me, again, that she'd like to lease the field. I started to say no, and before I could get the word out, she said, 'You'd better think about that.'

"I asked why I should and she said, 'You know that little house you're building? I understand the county doesn't know about it.'" Joanie took a deep breath.

"Oh my God," I said.

"That's right. She pretty much told me she'd turn me in to the county if I didn't lease the field to her."

"I can hardly believe it."

"Believe it," Joanie said grimly. "She meant it."

"You're right," I said, "she's a bitch. A real bitch."

There was silence for a minute. I knew, as well as Joanie, what

a bind she was in. For the last month she'd been having a contractor build a small cottage behind her house. It was in no one's view, and was a tiny structure, meticulously done. Joanie intended it as the future residence of some live-in help—an attempt to stay in her own home as she got progressively frailer and in need of assistance. The building was being done sans building permits, since the Santa Cruz County building department was legendary for its arbitrary and draconian restrictions and its exceedingly expensive and completely unnecessary requirements. In short, a permitted building would inevitably cost at least twice as much as an unpermitted structure and would almost invariably end up in a different spot and be in many ways quite other to anything the owner had originally intended.

Unpermitted "granny units" were the rule rather than the exception in this county. Everyone who could get away with it built them this way and they were as common as pebbles in a stream. In a place where the cost of housing was as high as anywhere in the United States, the granny unit was ubiquitous.

Unless, of course, you had a difficult neighbor. A neighbor who would call the quasi-hostile minions of the building department and sic them on you. This could put an immediate stop to your construction project. Most right-minded people didn't bother with such behavior unless said project was right in the way of their view or would in some way interfere with their lives.

In this case, Joanie's little house was not visible from Lindee's property, and given the huge amount of traffic coming and going at Lindee's place, it was hard to see how she could object to Joanie having a single tenant. Nope. It was blackmail pure and simple.

"That is really shitty," I said out loud.

"I know it is, but what can I do? I don't want to do this to you, and I love Danny and Twister, you know I do, and the last thing I want is anything to do with that damn Lindee, but what else could I do but agree?"

"Shit," I said, with some feeling. "You know Lindee's doing half a dozen things that are illegal, from the building department's

point of view. She's got a barn girl living out there in a travel trailer, for heaven's sake."

"I know. And I thought of that, too. But it isn't going to help me to get in a pissing contest with her. Once she's called the county on me, I've got a problem."

"I know it. If those damn building inspectors get started with you, you're screwed. I do understand. Guess I'm just going to have to find another place to turn out my horses."

"I'm so sorry, Gail." I could tell that Joanie meant every word. "I'd like to kill that woman."

"Me, too," I said fervently. "Me, too."

Chapter 2

I HUNG UP THE PHONE with a feeling of dismay. It wasn't that I didn't have anywhere to put Danny and Twister. They could go back in their corrals for the time being, until I found somewhere better for them. It was just the unreasonableness of the whole situation, the sheer misfortune of being saddled with a bitch like Lindee Stone as a next-door neighbor.

Walking out on my porch, I stared down the hill at the bank of oak trees that shielded my property from hers. If only looks could kill.

If I didn't have a baby, I thought, I'd march on down there right now and bawl her out in front of God and everybody. If I didn't have a sleeping baby. Which I did. At least, I hoped he was still sleeping. Better check.

Softly, I padded across the main room of the house to the bedroom door and peered in. The bedroom was small, just twelve feet square, mostly occupied by the antique bed and dresser I'd inherited from my parents. The rich brown, scrolling lines of the furniture showed to advantage against cream-colored walls, lit by the soft, indirect light from a large north-facing window. On one side of the bed was a small table with a bronze statue of Pan, playing his pipes; on the other a brand new co-sleeper bed crowded up against the wall. Mac slept peacefully in the small bed, his little face as perfect as a freshly opened rosebud.

For a while I stood and watched him, lost in amazement. Even when things were difficult, even when I felt the stress levels rising and my blood pressure creeping up, if I just gazed at Mac with an

uncluttered mind I could sense an underlying peace and tranquility seep back in. It was so apparent what a pure and perfect gift he was; even an overwhelmed fool, which I often felt myself to be these days, couldn't miss the message.

I tried to let myself stay with the feeling as long as I could, watching Mac sleep, knowing the still center was there under the turbulent waves of my outward life. Lindee or no Lindee, problems or no problems—and there were always problems—I was the mama of this wonderfully perfect creature, and that was what counted. I was happy.

A happy mama with problems to solve. With one last look at Mac's trusting face, I turned away and paced back into the other room. I would have liked to go down to the barnyard and check over the two empty corrals where I intended to put Twister and Danny, make sure they were fit for equine occupation, but I didn't want to get that far away from Mac. One of the tenets of motherhood that I'd embraced with a whole heart was that when a baby wakes the mama needs to be there. No baby should feel that his mama has abandoned him, not even for a moment.

So I paced back and forth across the room, picturing the corrals as well as I could, making mental arrangements when I was unable to make physical ones. And this, too, was part of motherhood. The constant compromise, the continuous frustration. As much as I loved my child, as much as I loved the quiet life I was living with him, I was also frustrated by all the things I couldn't do. Paradox.

Of course, truth resides in paradox. If I'd learned one thing in my forty years of living, it was this. Track anything down to its essential, underlying truth and you find a contradiction. Knowing this did not make it any easier to understand or live with. As Suzuki Roshi once said, "You're perfect just as you are; and you could use a little improvement." As much as I agreed with this statement, I had to admit that its lack of logical consistency was inherently frustrating.

Thus I loved being a mother, I considered it the greatest gift I'd

ever been given, and yet I was constantly frustrated. A very difficult thing to explain to anyone who has never been a parent. I certainly wouldn't have understood, pre-Mac.

Stepping out the open door, I paced back and forth on the porch, looking down the hill, past the vegetable garden to the horse corrals. Just visible dozing under the oak trees were Gunner and Plumber, the two horses I was currently keeping here for Blue and myself to ride. I'd owned Gunner for nine years and Plumber for eight; both horses were currently twelve years old and both were reliable, gentle mounts. I'd taken Mac for his first-ever ride on Plumber when he was all of six months old, and we managed to climb aboard (with Blue's help) and walk around the arena at least once a week.

As I gazed down at bay Gunner and cocoa brown Plumber, lazily swishing their tails, I pondered once again this odd dichotomy of motherhood. After years spent team roping, trail riding, and packing into the mountains on my horses, I now rode once a week, solely at the walk. And I was happy enough with that. What a change. Everything about motherhood was a change.

Restlessly I peered up towards the ridge. There, about halfway up, was a little hollow I'd discovered one day. It was level and floored with short turf, screened from prying eyes by the brush, but the screen was easy to peer through. Taken with the spot the moment I'd found it, I'd built a narrow trail up there and dragged up two comfortable folding chairs. From my hollow in the hills I could see out over my own property as well as my neighbor's, all the way down to the road and across to the hills beyond.

From this spot I had a clear view of Lindee Stone's ranchette, something I had never been much interested in. But now, for the first time, I had the impulse to spy on the woman, see if I could discover something that I could use as a counter threat. Surely, given the nefarious nature of many of Lindee's deals, I would eventually discover something she didn't want known.

Looking back over my shoulder, I pondered my options. Mac

would wake soon enough, I reminded myself. We would make the trek up to the hollow together, something we often did. He liked to toddle around on the soft turf.

Once again I stepped into the house, paced quietly to the bedroom, and peered at Mac. Sleeping peacefully.

Slipping back into the main room, I gazed around at the chaos. My small house was roughly seven hundred square feet, total; the bulk of this space being a twenty-by-twenty room that functioned as a living room/dining room/kitchen/office. This had been an entirely successful arrangement for many years, before Mac came along. And even when he was a babe in arms, the space had seemed sufficient. But now, now that he was a walking, toy-flinging toddler, things were suddenly different.

Now the floor was constantly carpeted with an assortment of wooden blocks and stuffed animals, not to mention spilled rice and bits of squashed banana. At the sight of the latter, I stuck my head out the door and called the dogs.

They came trotting eagerly, used to their role as cleanup crew. Little liver-and-white-spotted Freckles easily outdistanced the red Queensland heeler named Roey, who shuffled awkwardly. I shook my head as I watched her. Roey had been diagnosed last year with incurable degenerative myolopathy. The disease did not cause pain, but rather a progressively worsening paralysis; in all probability Roey would eventually be unable to walk.

The two dogs "vacuumed" the floor with enthusiasm. I wondered, not for the first time, how in the world I was going to deal with a completely crippled dog and a two-year-old. It seemed a daunting prospect.

You're not there yet, I reminded myself. Right now you have a one-year-old baby and two dogs who can both walk and are really great with your kid. Right now things are fine, or relatively fine, anyway, if you don't count that damn Lindee Stone. Sufficient to the day is the evil thereof. All you have to deal with is what's happening now. There's no point in the "what ifs."

The dogs wagged their tails at me, hoping that I'd distribute a little more food on the floor. Telling them to lie down, I bent over, slowly, and began picking up toys.

My God, I was out of shape. The simple task of grabbing a sock monkey off the floor made me wince. I had never been slender; with my wide shoulders and hips, the words "strongly built" might once have applied. I had at least been reasonably fit. But, like my house, my body was completely different "A.M." (after Mac).

I'd gained twenty extra pounds in my pregnancy, and these had not magically melted away as I nursed, contrary to the optimistic prognosis in many of my parenting books. No, despite what sometimes felt like nonstop nursing for an entire year, those twenty pounds were still with me, settled largely around my waist and hips.

I sighed. One more ramification of motherhood. Or at least, motherhood at the age of forty. Perhaps I should have started younger. Of course, motherhood at forty had its advantages, too. I was more able to find that still center of truth that told me the twenty extra pounds weren't important, failing to pursue my career wasn't a problem, lack of spare income just didn't matter. What mattered was my child. I was pretty sure, given my somewhat driven personality, that these insights might have been beyond me in my twenties and thirties. They were a revelation to me at forty.

I laughed out loud as I heaved toys into the wicker chest, remembering a younger pregnant friend who had contemplated the wiggling baby in my arms with both delight and trepidation, an emotion I recognized, having felt the same way during my own pregnancy.

"You still have your life, right?" she'd asked, obviously not sure. "You still do the things you used to do. The baby just comes, too."

I shook my head. "Nope, sorry, Kelly, it's just not like that. Or at least it hasn't been for me. Having a baby changes everything; your priorities are completely different. If you parent the way I do, anyway."

"So what is it you do?"

Reluctantly I met her eyes. I'd had this discussion before, and it wasn't always, or even usually, productive or pleasant. Certain sorts of mothers, or mothers-to-be, were quite hostile to the sort of parenting I practiced. They didn't want their priorities rearranged. They wanted to stay firmly in charge of their careers...and have a baby, too. They envisioned day care at six weeks, and thereafter.

I tried to gauge how Kelly might respond. Granted, she was a determined career woman who ran her own business, but she'd also been a Peace Corps volunteer in Africa and had some positive experiences observing the customs of the indigenous tribes and admiring their parenting. I decided to venture an explanation.

"I guess the name for what I'm doing is 'attachment parenting' or 'natural family living.' I've heard it called both. What it really boils down to is that I'm raising Mac the way humans have raised their babies for hundreds of thousands of years. It's what our DNA tells us to do, what mammals in general do. It's only been in the last hundred years that some of the parenting styles that are common in America today came about."

"What do you mean?" Kelly looked puzzled.

I took a deep breath. Time to bite the bullet here. "It means that I sleep with my baby at night. What people call the family bed. That I stay with him and take care of him, instead of dropping him off at day care. That I'm nursing him until he's ready to wean. And for me, in particular, it means that I don't take him to crowded, noisy, unnatural places like shopping malls and supermarkets. I try to stay home a lot, give him a quiet, gentle start to his life."

"You don't go anywhere?" Now Kelly sounded aghast.

I laughed. "It's not that bad. We go for walks in the woods and on the beach. We go out to dinner at our local restaurant, where we can sit out on the deck. We ride my horse. We go to the Farmer's Market. We go camping. And I'm in the garden a lot. Anything that's outdoors in nature feels right."

Kelly nodded. "And you take the baby everywhere you go?"

"Pretty much." I nodded.

"Don't you sometimes need time for yourself?"

"Sure. And my partner is really supportive. I leave Mac with Blue when I need to do something without a baby. Even if it's just go be by myself and read a book."

"What about your career?" I could hear the trepidation in Kelly's voice.

I shook my head. "I know. It's a problem. I spent all those years building a career as a horse vet and now I'm just letting go of it. It is hard to do. All I can say is, my heart tells me that I need to be home with my child. I don't want to drop him off at some day care with strangers; it doesn't feel right to me. So, I'm not going back to work."

"Never?" Kelly sounded truly shocked.

"I don't know. Maybe part-time. Maybe. I'm still a partner in the business. I just don't know." I shook my head again. "All I know is that I need to be home raising my child right now and for the foreseeable future."

The last of the toys rattled into the chest as I finished replaying this conversation in my mind. Kelly had not been very happy with what I'd said; I understood. I probably would have felt the same myself, in her position. In her late twenties, ambitious, happily married, very interested in her work—she'd thought, like so many women, to have it all—baby, career, intact social life. My words were a bucket of cold water, drenching her pretty vision.

And yet, I'd tried to say, it isn't like it sounds, really. It's the most wonderful and rewarding experience I've ever had. It sounds like I'm giving up a lot, but really, it's been easy to do. It feels natural and right. It fulfills me.

I was pretty sure these statements hadn't resonated for Kelly. All she'd heard was the gloom and doom in my affirmation that everything changes. End of the life she currently valued.

I sighed. It was true. And it couldn't really be explained. You either felt the truth of it or you didn't. And if she didn't, she would

become one of the many mothers who put their babies in a crib down the hall, fed them formula, and packed them off to day care from dawn to dusk, feeling justified in their need to prioritize their career. It was a choice every woman had to make for herself.

Moving to the sink, I began washing the blue willow patterned plates and the curving baroque silver that my mother had left me, stacking things neatly in the wooden drying rack as I rinsed them. The rhythms of life at home came more or less smoothly to me now; they seemed natural and fraught with meaning. The last dish clean and in the rack, I drained the water out of the sink and cocked my head. Had I heard something?

At the thought, it came again, the softest of bleats, barely a murmur. Quickly I padded across the room and into the bedroom. Mac was stirring, stretching and waving his limbs, blinking his eyes.

I smiled. "Wake up, baby," I said. "Let's go for a walk."

Chapter 3

TEN MINUTES later we were headed up the trail to "the hollow," Mac perched in his woven cotton sling on my hip. Sun slanted between branches of the live oaks, lighting twisting, charcoal-marked gray trunks in muted, glowing silver blotches. Loose tan and brown duff underfoot was dappled in the lively, mutable patterns of the shade that flickers through an oak tree. Then out into the sunshine—long late-afternoon rays making a halo of Mac's fine, fluffy curls.

Puffing a little, I lugged my baby up the steadily steeper slope, knowing there wasn't far to go. Ceanothus and greasewood formed a dense olive green shrubbery; the trail wound between snaking arms of their trunks, and I bent my head and shielded Mac from swiping branches with my free arm. Another step, the steepest one, and I ducked into a sudden clearing invisible from below.

About thirty feet in diameter, completely level and carpeted with short, soft turf that was hovering at the moment between silvery green and bleached gold, the hollow had been completely unexpected on the afternoon that I'd discovered it, hiking through the steep, brushy hills behind my home, curious to see just what was up there. Brush mostly, I'd found, thick with thorny wild blackberries, poison oak, and thistles, not the pleasantest vegetation to push through. I'd been on the verge of giving up the whole expedition as pointless when I'd stumbled upon the hollow.

What had caused it? I didn't know, though there was the slightest of V-shaped gullies above it, barely an indentation in the sandy hills, pointing like a partially concealed finger to the completely

hidden hollow. At one side of the circular clearing a largish multi-trunked live oak, the biggest oak on my entire property, cast a dense, mossy shade, populated by a bank of ferns. The rest of the clearing, which faced south, was in full sun most of the day.

At the moment my two chairs were set up in the sunshine, since in often-foggy Santa Cruz County, sunshine was usually the desired commodity. Here I sat, rear end in one chair, feet on another, sometimes nursing Mac, sometimes reading, sometimes just staring straight out in front of me. I'd placed a small statue of Buddha under the oak tree; a ceanothus bush at the other end of the hollow sheltered St. Francis. Both faces wore slight, beatific smiles, and I smiled myself every time I looked at them.

From this hollow I could look down over my property, over the green metal roofs of the house and the barn, the neat plot of the vegetable garden, the more distant rails of the horse corrals with the blue hills beyond. And just beyond my fence, if I stood in the right spot, I could see Lindee Stone's horse training operation, laid out in its entirety.

There was the bulk of the twenty-stall barn, the main arena, a large round pen, a row of pipe corrals, and a small pasture, all crowded with the moving shapes of horses and people. Friday afternoon appeared to be a busy time at the boarding stable. Off to one side, the plain ranch-style house was flanked by a travel trailer in which the barn help was housed.

Mac wiggled impatiently and I lifted him out of the sling and onto the turf, where he immediately sat down and plucked a stem of grass. Watching him with one eye to make sure he didn't eat it, though that was not his way, I reached into the sling and dug out the object I had shoved in behind Mac, somewhat to his consternation. Binoculars.

After another glance at Mac to be sure he was okay, I raised the binoculars, adjusted them, and presto, I could see. Not freckles, maybe, but I could see enough to recognize people that I knew.

There, for a start, was the obnoxious blond Lindee, easily spot-

ted, training a sorrel-and-white paint horse in the main arena; three blue barrels were set up in the familiar triangle and Lindee was schooling the horse in the cloverleaf pattern. Attempting to school him, anyway. This particular horse looked pretty resistant, rearing and running sideways in an effort to avoid approaching the first barrel. Lindee wasn't cutting him a whole lot of slack—what appeared to be a quirt and spurs were being used on the horse with considerable force, but so far he didn't seem convinced.

Nothing new here. From years as her veterinarian, months as her neighbor, and just general experience in the horse community, I knew perfectly well that Lindee's training methods were rough. I might not approve or agree, but there was little that I could do about it. Moving away from the expected, but nonetheless unpleasant sight of Lindee beating up yet another horse, I scanned my binoculars around the ranch.

There was a lot to see. I moved slowly through the various people riding horses and walking about, looking for folks I recognized with the vaguest of general thoughts that the knowledge might come in useful.

In the round pen next to the main arena, another tall, blond woman that I thought was the assistant trainer, Sheila Ross, appeared to be giving a riding lesson to a child. At least, a stoic-looking white pony was trotting in patient circles with a little girl on his back while the woman in the middle of the ring talked in their general direction. Yet another tall, blond woman—at a guess the mom—leaned on the fence, watching.

I sighed. These Western horsewomen seemed to come in a generic type. Tall and blond and lean, with high cheekbones, a good strong jaw, and a double-tough look. I had met my fair share of these horse gals over the years and there was something a little unnerving about them. They were pretty enough; for that matter Lindee Stone was pretty enough in the standard sense of the word, but there was something off-putting, at least to me, in that polished, hard exterior, the perfect makeup and tan, the expertly

streaked golden hair. They grated on my not-so-perfect nerves. Perhaps it was just envy, but they didn't look human to me, these women, they didn't look real. They looked like clones of a second-rate soap opera star.

"Sour grapes, Gail," I said out loud, causing Mac to turn his head curiously in my direction. Just because I was currently twenty pounds overweight and sometimes forgot to brush my teeth and hair, let alone apply makeup, did not constitute a reason to dislike those who found time for fitness and cosmetics. Still, I couldn't rid myself of the profound conviction that a certain type of glossy-looking woman—Lindee Stone's type—was very unlikely to be concealing a heart of gold beneath her fancy exterior.

Scanning with the binoculars some more, I recognized a pickup truck parked near the hitching rail. That was Jake Hanson's truck. And sure enough, there was Jake, bent over the left front foot of a paint horse tied to the rail in the immediately identifiable stance of a horseshoer.

Lindee used Jake as her shoer, then. That was no big surprise. Jake was as much the "golden boy" of his trade as Lindee was the star of hers. Just as tall, blond, and handsome as the women I'd been rolling my eyes over, Jake was a moderately good horseshoer and a compulsive flirt. His long-suffering wife, Rita, worked for our clinic as a vet tech, and I'd heard plenty of stories about his escapades.

Standing in the barn door watching Jake was a dark-haired man that I couldn't place, though he looked familiar. The short, brown-haired girl leading a bay horse out of the barn was Nina, who lived in the trailer and fed the horses and mucked the stalls.

Even as I watched, another pickup pulled in the driveway and a slim man with light brown hair got out and stood there, looking around. I pressed the binoculars to my eyes a little more tightly. Now this was interesting. If I was not very much mistaken, this latest arrival was Scott Stone, Lindee's ex-husband, who by all accounts detested her about as thoroughly as a man can detest an ex—

pretty damn thoroughly, perhaps even as much as I did at this very moment. So, what, exactly, was he doing at her place?

Before I had time to do more than consider this, Lindee emerged from the arena and strode across the barnyard, leading the paint horse she'd been riding. Nina grabbed the bridle reins as Lindee flung them in her general direction. At the same moment two women, one blond, one dark, converged on Lindee from opposite directions, both talking with a great deal of animation. I couldn't really see the expressions on their faces but their body language looked upset. At a guess, unhappy boarders or clients. I thought I recognized the dark woman: Kim Salter, who'd been a veterinary client of mine.

There was so much going on now, it was hard to follow it. I swung the binoculars back over to Scott Stone to find him engaged in conversation with a man and woman who I thought were Charley and Roz Richards. If I remembered right, Roz currently had several horses in training with Lindee, and Charley, her husband, was or had been good friends with Scott when he'd been married to Lindee. Wishing I could hear what this group was saying, I panned the binoculars around the ranch again.

A sudden squawk from Mac very nearly made me drop them. My toddler had toddled—unsuccessfully—over an outstretched ceanothus branch, and landed with a small thud on the turf. I smiled and said, "You're okay," and after a minute he smiled back and picked himself up. That was the thing about Mac. Minor adversity didn't set him back much. I returned my gaze to the training stable.

Lindee was seated in front of the barn; the white plastic table and chairs placed there clearly had "trainer" written on them in invisible letters. She appeared to be drinking from a glass of brown liquid and addressing—at intervals—a small crowd that had gathered around her. The only other chair had been taken by the dark-haired man who I'd seen standing by the barn. He didn't appear to be saying anything to anyone.

Various other people milled around the barnyard and environs, catching horses, leading horses, saddling horses, and riding horses. Mostly female, but a few males, too. Some I thought I recognized, most I didn't.

Scott Stone, I noticed, hadn't joined the group that had gathered around Lindee. Instead, he was moving towards the house. Shifting my binoculars, I saw a small figure sitting on the porch, and my heart contracted. Of course. Her little boy.

I'd forgotten that Lindee had a child. He was seldom about in the barnyard and didn't seem to play a very big part in her life, and yet by all accounts he lived with her, except for weekend visits with his father. Jared, was it? Maybe six or seven years old.

Once again I felt the tightening in my chest, as if someone was squeezing my heart in a fist. Six or seven was light years away, it seemed, from the thirteen-month-old pulling up stalks of grass in front of me. But I couldn't help picturing my own little boy at that age, imagining him largely ignored by a mother who valued her career more than her child and shuttled her kid back and forth from household to household. It didn't bear thinking about. I stared hard at the small figure on the porch who sat watching Scott Stone approach and blinked back the tears I could feel rising.

The man sat down by the boy; they appeared to be talking. I watched them for a while and then swung the binoculars back to the barnyard.

Lindee was still sitting, alternately sipping and talking. Roz Richards had joined the group around her; that wildly curly auburn head was instantly recognizable. A woman with long, straight brown hair was standing at the head of the horse Jake Hanson was shoeing. I squinted. That was Rita, his wife, who worked for our veterinary practice as a tech, holding difficult horses. I hadn't noticed her earlier, but sure enough, there was her distinctive bright red pickup parked by the barn.

I sighed. Glanced back at Mac, who was still pulling up grass. So far he hadn't put any in his mouth. This scrutiny of Lindee's

barnyard was interesting, in its way, but I didn't suppose it was really doing much good. What I really wanted to do was march right up to the woman and tell her that she made an enemy out of me at her peril, that just as she could cause trouble for others, I could cause trouble for her. I would threaten to turn her in to the building department for housing her barn help in an illegal travel trailer. Picturing this speech in minute detail was giving me a good deal of pleasure.

When Blue came home, I decided, I was going to put this plan into immediate action. What harm could it do? I didn't care if the woman hated me, and if by chance it caused her to give up her idea of booting my horses out of Joanie's field, I would be one happy camper.

Turning to my right, I swept the binoculars over the ten fenced acres across the street from Lindee Stone's driveway and located bay Danny and dapple-gray Twister immediately. Heads down, grazing in the sunshine, they looked as contented as two horses could look. I smiled, a little sadly. Both horses suffered from serious injuries that weren't really fixable; Danny had a diaphragmatic hernia, and Twister had torn up his meniscus joint in a collision with a truck. Twister was healing—very slowly; every year he was a little less lame. Even so, I'd owned him for about two years and he was a long way from being sound enough to ride. And Danny would never be able to breathe normally again. He puffed as if he had heaves. Turning them out in a pasture like this was the best life I could give them. The only good life I could give them. It just wasn't fair to pen them up in corrals for the rest of their lives.

Compressing my lips in annoyance, I vowed I would do something about Lindee and the threat she posed to Danny's and Twister's happiness. And soon.

Motion in my peripheral vision caught my attention and I jerked my head to the left. A dusty, dark green pickup was bumping up my badly rutted driveway.

Blue was home.

Chapter 4

I'D LUGGED MAC, squalling a protest, down the hill before Blue had even managed to park his truck and get out.

"Can you watch him for a while?" I panted, shoving my wailing baby in the direction of his father. "I need to go do something. Down at the neighbors." I didn't want to explain my mission; Blue would no doubt have counseled against it.

Holding out his arms, Blue picked Mac up and held him, at the same time regarding me with a quizzical expression. I'm not a short woman, but Blue's six and a half feet cause me to tilt my head back in order to meet his eyes.

"It will only take a few minutes," I promised glibly.

"All right." Blue nodded. "I can do that." His calm, almost grave tone was typical of Blue, as was the lack of questions. My quiet, reserved husband was almost always willing to let me take my own road without argument, though I could see a suspicious gleam in his blue-gray eyes. Blue knew me well enough to know that my agitation meant I was up to something.

"Thanks," I said quickly, kissing Mac on the forehead. "I'll be right back, baby." And I set off down the driveway as quickly as I could, hoping that neither one of them would call me back.

No wails. No protests. Mac was usually happy to be left with Blue. Blue was always happy to see Mac at the end of a workday. I looked over my shoulder. Blue was lifting Mac high in the air to accompanying trails of giggles. Good. I was free. For the moment, anyway.

Striding down the gravel driveway as quickly as I could, hoping

to round the corner at the bottom and be out of sight before either one of them focused on my departure, I pondered yet again the odd contradictions of motherhood. There were moments when I was desperate to get away—to do something, anything, sans Mac— and this impulse was inevitably swallowed up, sometimes within minutes, by the longing to be back with him again. Even on a brief solo trip to the grocery store, anticipated with much eagerness, I would suddenly feel swept by a desire more intense than I could fathom, a need to have Mac back in my arms. It was very odd.

But at this moment my attention was still flowing outward. Down the hill, toward my goal. Solitary and without encumbrance for once, I was going to face my problem head on, in the old Gail McCarthy manner.

Of course, the thought struck me, even as I walked out my front gate, I really wasn't the old Gail McCarthy anymore. I didn't even look like her. I was a slightly plump mama—I looked down— wearing baggy cargo pants and a not-too-clean red hooded sweat-shirt. My bare feet were shoved into battered huarache sandals that would certainly look out of place amidst a crowd of cowboy boots, and I couldn't quite remember if I'd happened to brush my hair or teeth this particular morning. I certainly wasn't going to be a very impressive or imposing sight.

So what? I lifted my chin and tried to buoy myself up with the energy of righteous anger. What did it matter what I looked like? The point was the same: Lindee Stone would regret it if she made an enemy of me.

Now that I was nearing her driveway, some of my outrage was swallowed up by anticipatory jitters. My heart thumped as I looked up to see a red pickup bearing down on me. I jumped sideways and then smiled. It was Rita.

The truck pulled up next to me and Margarita Hernandez rolled the window down and gave me a faint smile in return, though I thought her underlying expression was strained.

"Gail, what are you doing here? Got a barrel racing prospect you

want trained?" Rita's tone was teasing, but again, I didn't think it matched the look on her face.

I shook my head. "I've got some not-so-pleasant business to discuss with Lindee," I said grimly.

About my age, or so I would guess, Rita at roughly forty was at least ten years older than her handsome husband. Though she wasn't conventionally pretty, it was easy to see what had drawn Jake Hanson to her. Taut and trim, with olive skin, clear, hard brown eyes with faint smile lines raying out from the corners, and a long mane of shiny brown hair, Margarita Hernandez reminded me somewhat of a glossy feral cat. There was something tough and not quite tame in the energy she breathed. I'd worked with her before and knew her to be a good hand with a difficult horse, and a decent human being. I couldn't imagine why she put up with her flirtatious pretty boy of a husband, but, hey, everybody's got different priorities.

"So what are you up to?" I asked.

Rita shrugged. "I just got off work myself, thought I'd come by and say hi to Jake."

Once again, I was struck by the distinct impression that she did not look happy. And then again, I probably didn't either. Who could be in a good mood in the presence of Lindee Stone?

"I'd better go," I said. "I've got to talk to the queen bee."

Rita's mouth tightened. "Queen bitch, you mean." Then she smiled. "Good luck with whatever it is."

"Thanks. I'm sure I'll need it."

The encounter had served the purpose of relaxing me; I trudged up the driveway with a little less tension in my jaw. Glancing around the barnyard as I walked past the parked trucks and trailers, I noted that most of the people I'd spotted earlier were still in evidence, with the exception of Scott Stone. The tall, blond woman I had seen giving riding lessons, Sheila Ross, if I remembered right, was engaged in what appeared to be an intense conversation with Jake Hanson; perhaps this was the cause of Rita's sour expres-

sion. The phlegmatic-looking white pony was tied to the hitching rail in the sun, while the little girl who had been riding him was nowhere to be seen. The pony waited with apparent patience, still saddled and bridled, his blue eyes calm and unexpressive. On closer examination he wasn't entirely white; he had a sorrel spot on top of his head and another on his left flank. A medicine hat paint, in fact.

My eyes drifted past him, searching for Lindee. The table by the barn was still occupied by the familiar-looking dark-haired man with the mustache; Lindee's chair was vacant, her empty glass set down in her spot. The man met my eyes and raised his own glass in my direction. I nodded and turned away. Where was Lindee?

Not immediately apparent, but another blond woman moving rapidly in my direction made me wince. Oh no. Not Tess Alexander.

Tess's blond hair made a fluffy halo around her face, her eyes were big and blue, and her expression was, as usual, overwrought.

"Gail!" she greeted me. "You're just the person I need. It's Bella. I've got her in training here and it's not working out. She's struggling."

"I'm sorry." I tried to sound calm and polite, rather than unreasonably eager to dash in the opposite direction, which was how I felt. "I'm not really here in my professional capacity. I'm just visiting."

Tess kept talking; I didn't really listen.

Tess was one of my veterinary clients—one of my past veterinary clients, rather. And one I was quite glad to leave in the past. A person of no particular horsemanship skills, she'd acquired a young paint mare and was proceeding to do all the wrong things with her, albeit with the best of intentions. At the moment, judging by her impassioned diatribe, Tess had chosen to put Bella in training with Lindee Stone, on the mistaken impression that barrel racing was in the mare's genes, and was thus her intended destiny.

"But she's suffering, I know she is, I've told Lindee, but she

doesn't seem to listen. Lindee's way too hard on her; Bella's really sensitive."

Observing Tess's animated monologue, I was suddenly aware that this was the agitated blond woman I had seen approaching Lindee earlier, while I was observing—well, spying—through the binoculars. I just hadn't recognized her from such a distance.

"Lindee keeps saying I have to leave her here, she needs more work, and I'm behind on my training fees and I just don't know what to do. Bella's miserable here, and so am I." And Tess burst into tears.

I sighed inwardly. Tess was always having problems of one sort or another; it seemed to be her karma. Nonetheless, having her beloved mare in training with Lindee Stone was bound to be a mistake.

"Take the mare away," I said curtly. "Lindee can't stop you."

"But I owe her money," Tess said plaintively, "and I don't have it."

"Take the mare away, anyway. Pay her when you can. That's my advice. I'm sorry, Tess, I need to find Lindee."

Tess wasn't easily discouraged. She tagged at my heels as I walked through the barn, still talking and complaining, and it was only as I approached Nina Harvey that Tess shied off, for what reason I wasn't sure.

Nina was assembling bales of hay on a four-wheeled cart, getting ready for evening feeding. With a stable of more than forty horses, evening feeding was a big chore. I smiled at her. In our few previous encounters, I'd liked Nina Harvey.

Short and somewhat stout, Nina had curly light brown hair, direct blue-gray eyes, and a sense of humor that went with what I saw as a down-to-earth, pragmatic personality. Nina was the quintessential peasant, in my view, the one who got things done, while the people around her batted ethereal dollar signs and pedigrees around.

"Do you know where Lindee is?" I asked her now.

Nina shrugged. "She just took Dandy out to the arena."

"Dandy?"

"Dandy Doc. Fancy palomino paint. Does not at all want to be a barrel horse. But his owners have lots of money and they want him to be one. Lindee's persisting."

"Right." I knew what this would amount to. More whip and spur applied to a reluctant horse. "I'll go find her."

Nina made no reply, just kept loading bales on her cart. I went out the back door of the barn and turned right, moving in the direction of the big arena.

And there she was. Approaching the first barrel of the triangular pattern on a flying horse. A horse running at top speed, anyway.

A showy dark golden palomino with a few big white patches, Dandy Doc looked like a pretty good barrel horse from where I was standing. Even as I walked toward the arena fence, he made the first turn in fine style, sticking his hind leg deep in the ground and arcing his body to round the tight corner, then driving off his back end with real power as he stretched out toward the second barrel.

Flat out across the arena he raced, Lindee looking cool and poised on his back; they made the second turn like real pros, the horse's inside hind leg planted as he whirled neatly around the big blue can and raced towards the third oil drum. This last barrel was just across the fence from me. I took a deep breath. Lindee Stone and mount were charging straight in my direction, mane and hair flying. For a moment I forgot my purpose, forgot my anger, forgot everything, caught up in the wild force of the thundering hoofbeats, the hard, grunting strides, dirt clods rattling against the fence boards. The horse's eyes stretched wide and shiny, his nostrils flared red as he puffed; sweat gleamed on his shoulders; his mane lashed his rider's face.

Now came the third barrel, in some ways the most difficult turn in the cloverleaf pattern. I could see the horse gather himself to check and make the U-turn that would send him back to the finish line. Everything was right, smooth, focused, flowing—and then it wasn't.

Instantaneous fear in the horse's eyes as he jerked and broke stride—my own shocked gaze shot to the rider as I felt the rhythm fall apart. Lindee's face was twisted, her head thrown back, her hands pulling on the reins as her body bent backwards; the horse slid to a stop and reared straight up in the air. Up, up, up, he went, his body hanging ominously vertical, seeming to hang there forever. Lindee was already falling, dropping from the horse's back to the ground, even as her hand still attached to the reins pulled on the horse's bit.

Frozen in my place on the rail, I watched helplessly as Lindee's body thudded limply into the dirt of the arena. For a second the horse's body hovered over her, his shadow engulfing her still form. As if in slow motion, his weight tipped past the balance point, and he crashed over backwards, falling on top of Lindee with a jolt that shook the ground.

I couldn't move; I couldn't speak. Some distant part of my brain told me I should do something; what, I wasn't sure. The big palomino horse lay still for a moment, his body completely obliterating Lindee's, and then he moved convulsively. He thrashed again and suddenly lunged upwards, getting to his feet with his head down. And Lindee lay still. Ominously still.

I could hear people shouting, could see them running. I slipped through the rails of the arena and started toward Lindee's side. But even as I reached for her arm to take her pulse, I knew beyond a doubt that it was useless. Lindee Stone was dead.

Chapter 5

IN ANOTHER MINUTE Jake Hanson was bent over Lindee's body, starting CPR.

Sheila Ross grabbed my arm. "What happened, did you see? I was in the barnyard. I saw Dandy go over backward but I didn't see what made him do it. What happened?"

"I don't know," I said vaguely, staring at what I could see of Lindee. I was holding her wrist and feeling for a pulse, but I couldn't find one. Jake was trying hard to revive her but I knew it wouldn't work. I didn't know how I knew; I just knew. Lindee was gone.

"How did it happen?" Sheila demanded again.

"I don't know." I really didn't know. I had seen it but I didn't understand it. It didn't make sense.

Roz Richards was standing behind Sheila; I could see the cell phone in her hand. "I just dialed nine-one-one," she said. "Ambulance is on its way."

We all watched as Jake pressed hard on Lindee's chest and then blew into her mouth. I felt that deep inner certainty that it was pointless. Lindee had been dead when I reached her.

And then, in the midst of the shouting, milling group of people who were gathering around us, the enormity of it hit me. I had wanted her dead, I had wished out loud for her death—and here she was.

"My God," I said.

Sheila looked at me. "What happened?" she asked again, more insistently.

I knew what she was asking. What had happened to make Dandy

Doc flip over backwards and land on Lindee? Lindee was a pro; she ought never to be caught unaware like that. She'd ridden many, many rank horses in her life and knew all the tricks.

Sheila shook my arm. "Dandy can be a pain, but he's never done anything like that. Why didn't Lindee jump clear?"

I stared at her agitated face. It felt as if I were in some sort of cocoon; nothing seemed real. I replayed what I had seen; it didn't make sense.

"I don't know," I said yet again. "I don't understand it."

"You saw it, didn't you? No one else was close."

"Yeah, I saw it," I agreed. "It was weird. The horse just reared up and went over backward. For no reason, it seemed like."

Again and again, I replayed the moment when Dandy Doc had faltered, slid to a stop, and reared up; there was something very odd about it. Something I wasn't ready to confide to Sheila Ross.

The distant wail of sirens was now perceptible. Several people in the group turned their heads toward the road. Tess Alexander was still here, I saw, along with Roz and Charley, Kim Salter, Nina Harvey, who held Dandy Doc's bridle reins, and the dark man whose name I didn't know. He stood near Lindee's head, looking down at her with an expression I couldn't place. He looked almost mystified, as if he didn't believe what he was seeing.

I glanced at Dandy Doc, who stood on all four legs and seemed fine, if winded. Then back at Jake, who still labored steadily over Lindee. The sirens were louder now; I could see the flashing lights coming down the road toward Lindee's place. Two sets of them. An ambulance and a black-and-white Highway Patrol car. At the sight, a rush of thoughts came crowding in. The inevitable questions, the gathering dusk, and Mac, my God, Mac. I'd forgotten about Mac.

I turned abruptly to Sheila. "I have to go. I'll be home, right next door, if anybody wants to talk to me."

"But—"

I didn't let her finish. "You know where I am." And I was off, moving rapidly toward the barn's back door.

Once inside the barn, I headed for the front door. The ambulance and the cop car were parked in the driveway now, lights flashing; all uniformed personnel seemed to be moving in the direction of the arena. The white pony still stood tied to the hitching rail; he nickered at me as I emerged from the barn. The message was plain: "Put me away and feed me."

"Sorry, fella," I said out loud. "I've got to get out of here before somebody stops me."

I slipped past the blinking ambulance and walked down the driveway, headed for my own front gate. Walking as fast as I could, not daring to break into a run lest it draw attention to my fleeing form, I felt unreasonably guilty. After all, I wasn't really running away from the scene of the crime, I reminded myself, it just looked it. They could find me easily enough.

Heaving a sigh of relief as I walked through my gate, I headed back up my own driveway. Blue had fed Gunner and Plumber; I could see their heads down, munching hay out of their mangers. Twister and Danny didn't need to be fed these days; their pasture was knee-deep in grass.

In another minute Freckles and Roey came running to meet me, or rather Freckles ran and Roey shuffled. I patted both their heads and looked around. No Blue in sight, though the chickens were shut in their brand new chicken coop, and the barn cats were munching crumble in front of the barn. Blue and Mac must have gone up to the house.

I marched up the hill past the vegetable garden, breathing in the sweet, early summer evening, aware of its calm beauty surrounding my harried spirit. I wouldn't, couldn't relax until I saw Mac and knew that all was well with him. It wasn't just the disaster I'd witnessed; this was my usual response to being reunited with Mac after an absence. I had to see him, feel sure of his wholeness, before my world was right.

Lights were on in the house; I opened the door to the sound of Blue's laughter. Everything was undoubtedly fine. Mac sat on

the living room rug, flipping through the pages of a board book, pointing at the pictures and making cheerful squeaks. And judging by the smells, Blue had put lasagna in the oven.

"I'm back," I called.

"Good," Blue answered. "We missed you."

"It's not good, though," I said as I walked into the room. "Lindee Stone just got killed in a fall from a horse."

"What did you say?" Blue turned to look at me directly, his face appeared as uncomprehending as I felt.

Despite the disjointed moment, I felt a huge surge of affection for my husband. With his face registering shock and disbelief, he was still calm and poised, his long red-gold curls, confined in a ponytail, the only electrifying thing about his demeanor. Blue was a steady, gentle, comforting presence at all times; I had come to rely on his good judgment and levelheadedness.

"A horse went over backwards on Lindee Stone and killed her. At least I'm pretty sure she's dead. The paramedics are with her now. I was the closest one to her when it happened. You must have heard the sirens."

I scooped Mac up and put him on my lap as I sat down in the moss green armchair by the window. Mac's little hands fumbled at my sweatshirt and I unzipped it and lifted the T-shirt underneath. His mouth latched on quickly and I felt the familiar tug of a nursing baby, deeply reassuring in the midst of my chaotic emotions.

"You saw this?" Blue still sounded disbelieving.

"Yep." I sighed. "And it was really strange. In more than one way." Briefly I recounted Lindee's phone call this morning and what followed, omitting my foray with the binoculars.

"So you went down there to confront her?" Blue watched me nurse Mac and added idly, "I fed him a whole banana; he's not really hungry."

"I know. We're just reconnecting. And yes, I went down there to threaten her, actually. And I told Joanie I wished she were dead."

"Oh no."

"Oh yes. And now she is." I sighed. "And I can't honestly say I'm sorry, though I never would have done anything to hurt her."

"I know that." Blue's deep voice was solemn. "But still."

"I know. I feel really strange about it. But there's more. Something I haven't told anyone. Because," I said slowly, "I don't know what to say. It's so weird."

"What is?"

"What I saw. Or thought I saw. I just don't get it." I replayed the scene in my mind one more time. Each motion, each nuance reinforced the bizarre scenario that I believed I'd witnessed.

"That's what I saw," I said mostly to myself. "And it doesn't make sense."

"What doesn't?" Blue sounded a bit impatient now.

I sighed. "I was down there at Lindee's place, looking for her. Nina Harvey told me she was schooling a difficult horse in the arena so I walked out there and found her. She was running this horse around the barrels and everything looked completely normal."

Blue nodded. He was a horseman and a team roper; he'd watched plenty of barrel racing and knew what normal would be.

"I'm no expert on barrel horses," I went on, "but the horse was running well and making the turns around the barrels nicely, as far as I could see. He wasn't trying to run out or throw his head up or doing anything else obvious. He looked really good. But just as he got to the third barrel he suddenly came apart. He got this scared look in his eyes and started to slide to a stop. I looked up at Lindee and she was pulling on him really hard, with a weird expression on her face. Almost a grimace. And then the horse reared up and went over backwards."

"Maybe that horse always tried to refuse the third barrel and Lindee was trying to correct him," Blue proposed.

"Maybe," I said dubiously. "But it really didn't look like that. The horse seemed perfectly willing up until that moment. I guess we could ask someone who knew him if that was his pattern.

"The thing is," I went on, "it wasn't just that. Lindee kept pulling and pulling on the reins, even when the horse was rearing straight up in the air. She never let up. And she didn't step off or jump to one side, either."

"You mean?"

"Yeah. That horse didn't flip over backwards with Lindee. She pulled him over."

Chapter 6

BLUE LOOKED INCREDULOUS. "And she made no effort to get out of the way."

"Nope. It's the first thing I thought of, too. Lindee was more than tough enough to pull one over on purpose."

This idea had occurred to me earlier, as I searched my mind to come up with a logical explanation for what I'd seen. Once in a while, a horseman of the old school would punish a horse for rearing up by pulling the horse over backwards on purpose. Some horses were so frightened by this experience that they would never rear again. It took a certain kind of person to do this: double-tough, competent, and a bit ruthless when it came to risking life and limb. Not only riders, but also their mounts had been killed when a horse reared up and went over backwards.

"She didn't even begin to get out of the way," I went on. "She had plenty of time, just like you would expect."

Blue nodded again. A rearing horse normally overbalances and goes over rather slowly; from atop its back the event almost feels like it's happening in slow motion. There's usually plenty of time for the rider to jump to one side.

Casting my mind back, I pictured Lindee's body dropping, and the long moment as the horse hung over her before he fell. Lindee had not scrambled away, as any normal person would have. Why?

"Maybe the fall knocked her out?" Blue suggested diffidently.

"It must have," I agreed. "But it didn't look like she fell that hard, just dropped off the horse's back into soft, plowed-up arena sand.

Hard to see how it could have knocked her out. To tell the truth, it looked as though she was already out when she fell."

Blue moved to the oven to check the lasagna, then began grating cheese. The two dogs, who had been sitting at his feet, ranged themselves, one on each side of him, waiting for some cheese to drop. Mac nursed busily on, one hand squeezing the side of my breast gently, for all the world like a kitten kneading his mother. "So, what do you think happened?" Blue asked me over his shoulder.

"I have a hard time imagining," I said slowly. "Unless she had a heart attack or something and passed out on the horse. But she was barely forty. It seems unlikely."

"Unless she had a heart condition," Blue pointed out, "or maybe it was a seizure. She could have had epilepsy."

"You're right. I hardly knew her well enough to know any of this stuff. I didn't want to know her at all. Let's face it; I wished she were dead and now she is. Not very pretty."

Blue said nothing for a while. Opening the refrigerator, he took out lettuce and began making a salad. Only after the bowl was full of romaine, spinach, and spring greens did he point out, "Your wish didn't kill her. For that matter, you don't even know if she's dead."

"I'm pretty sure she is, though. And here's the bad part, I'm not really sorry. I can't help thinking that my problem is solved. I know that sounds awful, but it's true. Twister and Danny can stay where they are."

Blue shook his head. "I hope you don't mention that to too many people. Someone will think you bumped her off."

"You're right. The thing is," I shrugged, "I bet there are lots of people who are feeling the same way right now. Lindee had plenty of enemies, and I don't know of anyone who really liked her."

Blue considered this in his quiet way as he added chopped almonds and grated cheese to the salad. "I didn't know her to speak of, just chance encounters since she moved in here. She didn't seem like a pleasant person."

"That's the understatement of the year. Lindee Stone was about the least pleasant person I can think of."

At that moment both dogs woofed; I turned my head to look out the window. Dusk was moving toward darkness; yellow headlights were plainly visible coming up the driveway. I squinted. That boxy sedan shape looked familiar.

"Shit," I said out loud, but without much force.

"What is it?" Blue's tone was calm, as always.

"I think it's the cops. I'm the only one who was close to Lindee when she fell. I'm guessing they want to ask me some questions."

"Surely this was an accident," Blue pointed out.

"I think they have to investigate any sudden death. I seem to remember Jeri telling me that."

I peered through the semi-darkness as the car came to a halt near the house. A plain, dark green sheriff's sedan, it looked like. The driver's-side door opened, and a woman got out. Sure enough.

I smiled and shook my head. "Speak of the devil."

"What do you mean?"

"It's Jeri Ward."

Mac lifted his head from my breast as both dogs trotted to the door, barking their heads off. I pulled my shirt down as we heard the brisk knock. The dogs escalated their barking. "That's enough," Blue said firmly, walking down the short hall.

I stayed seated, cuddling Mac on my lap, observing his intent expression as he viewed the commotion. I could hear Blue greeting Jeri, could hear the dog's barks subsiding to eager whines as they greeted the newcomer. Neither one of them was a biter, which Jeri knew quite well.

And then she was in the room, my occasional companion and longtime acquaintance, Detective Jeri Ward of the Santa Cruz County Sheriff's Department. "Hi Mama, how are you?" she greeted me. "Don't get up. And here's the little guy." She gave me an inquiring look.

"Mac," I said, "McCarthy Winter. He's just a little over a year old."

"He's a real cutie," Jeri said politely. I noticed she made no move in our direction, merely pulling out one of the chairs by the table and sitting down. As far as I knew, Jeri had no children.

"So how's the life of a mama treating you?" Jeri's keen eyes were fixed on me. I felt sure that no detail escaped her, from the messy strands of hair straggling around my face to the spots on my not-too-clean sweatshirt. We certainly provided a study in contrasts, as Jeri was as well turned-out as ever. Her charcoal-colored jacket looked like woven silk, her dark gray pants were miraculously unwrinkled, and her wavy blond hair, worn in a chin-length bob, was as tidy as if she'd just left the salon. I could not, for the life of me, figure out how she always managed to look so freshly pressed; it wasn't as if she led a sedate life.

"I love it," I said, in answer to her question. No need to go into detail about my occasional angst. "And how have you been doing? Still have ET?"

ET was Jeri's horse, who'd been in his twenties when she bought him several years ago. Long-backed and short-legged, with a neck like a giraffe and only one functional eye, ET fully deserved his amusing name. He was also one of the kindest and most reliable horses I'd ever had the pleasure to be around.

"I still have him," Jeri smiled, "and he's doing fine. I've got him turned out in a five-acre pasture near where I live, with another old horse. He's still sound, and I ride him once in a while, mostly at a walk. He's getting pretty stiff. I think he's almost thirty. But I really enjoy him."

I noted how much looser and more relaxed she sounded when she spoke of the horse; clearly ET filled a special place in Jeri Ward's rather hard-edged heart. Hard-edged for a reason. Being a cop is a tough job; I'd known Jeri for ten years now, and I knew how necessary her defensive composure was. Too many moments of danger, too many encounters with folks who wanted her dead, had honed her responses to a clipped and guarded tone. Cop speak, I called it to myself.

"I'm glad ET's doing well. He's sure a sweet horse." I smiled at

Jeri and she smiled briefly back, but almost as soon as it came the smile died, to be replaced by her customarily stern mouth.

"Motherhood doesn't seem to have kept you from finding trouble, Gail."

"What do you mean?" I protested. "In what way have I been making trouble?"

"I just came from Lindee Stone's place."

"So I figured. But I certainly didn't cause that wreck." Mac squirmed restlessly and I put him down on the floor.

"No, I don't suppose you did," Jeri replied. "But you were right there when it happened. At least that's what the assistant trainer said. No one else was very close, though a couple of people said they saw it. What happened?"

I could see Blue open the refrigerator and take out a container of rice. In another minute the rice was warming on the stove while Blue cut an avocado in half and removed the pit.

I met Jeri Ward's eyes and answered her question with another. "Is Lindee dead?"

"Yes. Paramedics couldn't bring her back." Jeri's voice was level.

"What killed her?"

"The horse landing on her, presumably. As for what exactly was damaged, we don't know yet. Autopsy will show."

"There'll be an autopsy?"

"Yes. It's routine, with an unexpected death."

I watched Blue crush the avocado meat into the warm rice. He picked Mac up, sat him down in his high chair, and offered him a spoon and the bowl of green mush. Mac scooped up a spoonful and shoved it into his mouth. Well, most of it went in, anyway.

Jeri observed all this with a bemused expression and turned back to me. "So what exactly happened with Lindee Stone and this horse? Did you see it?"

"I saw it." I sighed. "It doesn't make a lot of sense. I was just telling Blue. Lindee was schooling this horse on the barrels and something happened, I'm not sure what. But it looked like Lindee pulled the horse over backwards. Also, she fell off of him in a strange way,

as if she were already unconscious. She landed on the ground and just lay there, made no effort to get out of the way of his falling body. It was really odd. Blue and I were wondering if she might have had a heart attack or a seizure."

"That is odd." Jeri got a small notebook and pen out of her pocket and made some quick notes.

"Anything else you can tell me?" she asked.

I hesitated. "Did you know Lindee?" I asked her.

"No. I knew she was a horse trainer. Trained barrel racing horses. Pretty well known. That about covers it."

I wrinkled my nose. "I hate to say this, but you're going to find out sooner or later, and I want to be honest with you. A lot of people didn't like Lindee Stone. Including me."

Jeri stared at me. "What's that supposed to mean?"

"I don't know. Maybe nothing at all. It's just kind of funny, in a macabre sort of way."

"Are you suggesting there's something suspicious about this death?"

I spread my hands. "I'm not suggesting anything. I've told you what I know, which isn't much. But there was something very odd about that wreck, and, this is a terrible thing to say but I'm afraid it's true, I have a feeling that quite a few people may be relieved that Lindee's gone." I didn't add that I was one of them.

Jeri watched me with a blank, noncommittal look for several seconds. At last she spoke. "You know, Gail, if it was anybody but you, I'd say it sounded ridiculous. But you've been right before; your intuition's pretty good. Are you telling me you think someone killed this woman?"

I shook my head. "Jeri, I don't know. But I can't get it out of my mind. Something about it just doesn't feel right."

"Got it." Jeri stood up in one motion, smiling down at Mac, whose face was now covered in rice and slimy green avocado goo. "I'll keep it in mind." With a quick good-bye to Blue, she turned to go. And then turned back. "I'll be in touch," she said.

Chapter 7

SATURDAY MORNING DAWNED bright and clear. The statue of Pan on our bedside table lifted his pipes to a glowing band of aquamarine on the eastern horizon. Far off, very far off, I could hear a coyote howl. Close at hand, a rooster crowed. Mac stirred sleepily by my side.

Looking down at him, nestled between Blue and me, I saw the sweet, sleeping face and felt my heart expand. I stretched luxuriously; every inch of my twenty-pounds-too-rotund body felt utterly content. I wanted nothing, needed nothing, but this warm, cozy closeness with my family, cuddling together in our bed. Lying there quietly, I stared out the window as the light grew brighter over the eastern ridge and listened to the morning songs of the birds filtering in through the open screen.

Judging by Blue's snores, he was still asleep, as was Mac. After a few minutes, I slipped out of bed and padded down the hall into the other room to flip the switch on the coffeemaker and put the kettle on for tea. Prepared the night before, the coffee machine chugged into life; the kettle sizzled slightly on the burner. The pleasant, routine beginning of yet another Saturday morning at home.

It was really amazing, I reflected for a minute, watching the first long rays of sunlight shoot through the branches of the big eucalyptus tree, how attached I had grown to these little rituals of family life in such a short time. Single for all but the last two of my forty years, I had been obsessively independent for most of my adult life, fearing to need or even want another person too much. Perhaps the result of my parents' demise in a traffic accident

during my eighteenth year, this inability to feel comfortable in a committed relationship had persisted right up until the moment I'd agreed to marry Blue. Pregnancy had followed shortly, and now, a mere two years later, I was immersed in the sort of connected personal intimacy that had raised claustrophobic vibrations in my mind for years. Only to find that I loved it.

Quiet footsteps in the hall and Blue emerged from the direction of the bedroom.

"Is he still sleeping?" I asked.

"Yep." Blue lowered his long, rangy body, clad only in plaid boxer shorts, onto the couch. "Why don't you come here for a minute, you gorgeous creature."

I laughed and looked over my shoulder. "Who, exactly, are you talking to?"

"You know who. You, my beautiful wife." Blue held out his arms. "We need to take our opportunities when we can get 'em."

I grinned and settled myself down in the curve of his arm. It was true. The family bed was cozy, cuddling my baby at night was very sweet, but lovemaking had definitely declined. Both Blue and I were accepting; we'd wanted very much to be parents and were relishing the experience. But there was no denying that we some-times missed the old spontaneous freedom.

Blue bent to kiss me and I gave myself up willingly to the moment, aware that it would last only as long as Mac continued to sleep.

Fortunately, in this case, it turned out to be a good long time. Twenty minutes later, feeling considerably more satisfied, Blue and I were sitting next to each other, sipping coffee and tea, respectively.

"That was a nice start to the day." Blue looked quite smug, I thought.

"Mmmm," I agreed, taking a swallow of tea laced liberally with milk and sugar. I'd acquired a preference for tea over coffee during my pregnancy, and it seemed to be sticking with me post-baby.

The two dogs lay on the floor at our feet; they'd shifted from

the bedroom to this room when they heard the familiar chink of the coffee cups. Banned from sleeping on the bed now that we had a child, they seemed quite content with the rug next to it.

After a minute, I put my empty mug on the coffee table. "I think I'll walk down and feed the horses. It's such a pretty morning. Call me if Mac needs me."

"Will do," Blue agreed.

Zipping my faded sweatshirt over my T-shirt, and pulling on a pair of jeans, I shoved my feet into sandals and headed out the door. It would be nice to be alone in the garden, just for a minute or two.

Outside everything sparkled, bright with dew and sunshine. I could hear the "tee, tee, tee" of a little wren who lived in the brush and the bubbling song of a brown thrasher, sounding as if he were imitating his mockingbird cousin.

Strolling down the hill, I noted that the creamy peach Treasure Trove rose climbing up the pillar of the porch sent a drift of heady scent with me, as its arching canes seemed to reach for the blue sky above. Swiveling my eyes to the vegetable garden fence, I marveled at the mass of deep purple flowers on the old-fashioned sweet pea named Cupani. This color contrasted splendidly with the blush white rose blossoms of Madame Alfred Carrière, which draped itself over the next fence post. So much to look at, so many lovely things to see—it was almost too much. June is an abundance.

Plumber spotted me and nickered his shrill, high-pitched nicker, always the first one to call. Gunner echoed him, a deeper "huh, huh, huh." I watched my two geldings march eagerly between the oak trees, up the slope to the pasture shed where their feeders were. They looked bright-eyed and healthy, both sound, both glossy of coat. Walking to the barn, I grabbed two flakes of grass hay and flipped them into the mangers, pleased to see how keen the horses were for their food.

Meows reminded me that others were eager to eat, too. Glancing back at the barn I saw that the four barn cats were assembled by

their bowls. Everybody accounted for, then. My cat population had been shifting radically of late, due, I was afraid, to a pair of resident coyotes.

Of last year's three barn cats, only little tabby-and-white Baxter was left, his two brothers having disappeared sometime during the fall and winter. But during that same period Blue had trapped two feral cats out at the rose-growing farm where he worked and brought them back to be released here. They were quite at home now, so we had fluffy, charcoal-colored Cinders, and tabby Leo with a ruff around his neck like a lion's mane. They had both been neutered and given their shots before we turned them loose, and were currently doing their part to keep the rat and ground squirrel populations in check.

Then, last month, a co-worker, knowing Blue's reputation as an animal lover, had begged him to take another feral cat, so we'd just acquired dramatically orange-and-black-striped Tiger. After an initial disappearance of several weeks, during which we'd more or less given up on him, Tiger had suddenly reappeared again at feeding time and since then had become a constant presence in the barn.

I poured some crumbles in their bowls and smiled as the cats dove in. I was fond of my little feral cats; they mostly did not care to be touched, though Baxter would allow it, but they were lively, useful, beautiful creatures, prowling and playing in the garden, and I was happy to have them.

A loud crow from the chicken coop reminded me that I had one more group to look after. The banties were still awaiting freedom and breakfast.

Locking the chickens up at night was a relatively new development; I had always allowed my bantie flock to run free and roost in the trees. But we had lost so many lately to bobcats, hawks, owls, coyotes, and raccoons, to name only the major culprits, that Blue had built a coop this last spring and the chickens were duly shut in every evening.

I counted heads as I sprinkled hen scratch in the wire run—all nine adult chickens were there and accounted for. Three roosters and six hens, what remained of almost forty banties. The black hen had six half-grown chicks. I really didn't want or need forty of these critters, but I didn't want to lose them all—thus the coop.

Gange, the head rooster, stepped in front of me to crow dramatically; I paused a moment to admire him. Blue had seen this rooster a year ago at the feed store and been unable to resist. Jack, the former patriarch, had finally died of old age, my first chicken to manage this feat, and Gange was purchased to replace him.

Snowy white, with deep red patches on his shoulders, a brilliantly gold cape, and long arching white tail feathers, Gange was a splendid sight. When he first flew up on the vegetable garden fence to crow, it was as if an exotic pheasant had visited our garden. Since Blue felt that the chickens' main purpose was as "land koi"—providing the same movement and beauty in the garden as koi do in a pond— he was quite pleased with Gange.

Rob Roy, our second-string rooster, a more plebian but still beautiful fire red with a green tail, attempted a boastful crow in my general direction, but was interrupted by a sharp peck from Gange. Rob Roy squawked and jumped away, undaunted.

The roosters had a clear pecking order (literally), as did the hens, and everybody understood their position and seemed to get along. I sprinkled a little more hen scratch in the run and resolved to let the chickens out later; early morning was a favorite hunting time for bobcats and coyotes.

I was just making my way back up the hill to the house when the scrunch of tires on gravel caused me to turn sharply. I wasn't expecting company, so who the heck would be driving up my driveway at eight o'clock on a Saturday morning?

The dark green sheriff's sedan was instantly recognizable. Equally so the blond head behind the steering wheel. Jeri Ward was here.

Chapter 8

PULLING THE CAR UP beside me, Jeri rolled down the window. "Want to run an errand with me?"

"Now?" I asked, nonplussed.

"Yes, now. I'm on my way to tell Lindee Stone's ex that she's dead; I thought maybe I'd pick your brain a little more."

"Is this what you call 'questioning the suspect'?"

Jeri grinned briefly. "Well, yes, I do want to question you a little, but you're not a suspect. Not yet. This isn't a murder investigation, just an accidental death. Or so we think so far. We'll see what the autopsy shows."

"When will you have the results?"

"Monday."

"And what exactly do you want to question me about?"

"Oh, just background information. Do you happen to know the ex?"

"Yeah, I know Scott Stone."

"I thought it might be nice to have someone he knew with me when I broke it to him. Especially since you saw the wreck."

"I don't think Scott is going to be real upset about this," I said.

"Do you want to come?"

"Sure." I shrugged. "Let me go check in with Blue and Mac." Glancing down, I added, "Maybe put on something a little cleaner."

"I'll wait here." And Jeri parked her car in my driveway.

Back at the house, I found Blue feeding Mac oatmeal and peaches, both of them seeming quite content. Exchanging my sweatshirt for a not-much-dressier denim jacket, I told Blue, "Jeri Ward wants

me to run an errand with her. Think you and Mac will be all right
for a while?"

"Sure we will."

Since I had been leaving Mac with Blue ever since he was a new-
born, I knew this was true.

"I'll bring my cell phone," I promised, "in case anything comes
up." I placed this object in my back pocket as we spoke.

"Don't worry. We'll be fine." Blue smiled tranquilly, clearly in a
good mood.

"Okay," I said. "I'm off to do some sleuthing. See you." And I
kissed Mac on the top of his fuzzy little head, which smelled faintly
of tea, and left before anyone changed their minds.

Jeri Ward sat quietly, registering very little expression as I
climbed into the passenger side of the car. She puttered down my
driveway at a sedate speed and pulled out on the country road
that I lived on before she asked me, "How well do you know Scott
Stone?"

"Not well. He was married to Lindee for several years and she
was one of my veterinary clients. I would see him occasionally
when I was out there on calls."

"Where was there?"

"Lindee was training at a place called River Oaks Stable," I said.
"They didn't own it, I don't think, though she bought this place
next door to mine."

"Right," said Jeri Ward. "I checked. Her name's on the title. Her
will says that it goes to her son. Her ex is the trustee."

"Oh," I said.

"So what do you know about their divorce?"

"Rumor had it that it was nasty. But divorce often is."

"That's what I heard, too," Jeri said. "Apparently her ex is really
not fond of her."

"I would definitely agree to that. He lives down on Pleasant
Valley Road," I added. "His current wife has horses, too; I've been
out there a few times on calls."

Jeri grinned. "Some men never learn."

I smiled back and then shrugged. "This one's pretty different from Lindee."

"So what was Lindee like? I saw her body, so I know she was tall, blond, and athletic-looking; that's about it."

I shrugged again. "You're asking the wrong person. I've already told you that I couldn't stand the woman. In fact, I'm going to be one hundred percent honest and tell you that we argued yesterday afternoon and I quite sincerely wished that she were dead."

Jeri Ward's eyes swiveled from the road to my face and then back. "Is that right? And what did you argue about?"

I recounted the short saga and wound up with, "So I can tell you about her, sure, but I'm a little bit prejudiced."

"All right. I'll take that into account. What can you tell me about her?"

"She was a well-known trainer of barrel racing horses. She won at a pretty high level. She never had a great horse like Scamper, but she had some good ones. Everyone in the rodeo world knows her name. And I don't know many who would claim to like her."

Jeri took this in. "Who's Scamper?" she asked.

"Just the greatest barrel racing horse of all time. He was world champion maybe ten years in a row. I heard they cloned him. He was a gelding," I added.

Jeri whistled. "Pricey stuff."

"Yep," I agreed, "but Scamper was an amazing horse."

"So," Jeri said, "I hate to sound woefully ignorant here, but unfortunately I am. Could you explain exactly what barrel racing is? I don't really know. It has a funny sound, like the horse is racing a barrel."

I laughed. "Right," I said. "A lot of cowboys call it chasing cans. But no, the horse doesn't race or chase the barrels. The barrels are set up in a specified, measured pattern, and the horse races around them. It's a timed event. The horse's time starts when he crosses the line, then he runs what they call the cloverleaf pattern around the

barrels and when he crosses the line again, his time stops. Fastest time wins."

"So the horses run one at a time?"

"That's right," I agreed.

"And what, exactly, is a cloverleaf pattern?"

"The three barrels, which are essentially oil drums, are set up in this measured triangle. The horse runs a pattern that involves making a specific, ordered U-turn around each barrel and then racing back to the line where he started. The loops around each barrel look a bit like the three lobes of a cloverleaf."

"And what does it take for a horse to be good at this? Obviously he's got to be fast."

"Yeah, he's got to be fast, a certain kind of fast. He has to have a really good start and be quick over a short distance. Horses who take awhile to get up to speed are useless. Then he has to have the athletic ability to make those really tight turns around the three barrels and then go like hell again. It's very demanding; to be good at it, a horse has to be pretty tough-minded."

"What else can you tell me about barrel horses?"

"Well, good ones are expensive, by my standards, anyway. The best one Lindee Stone had, in the days when I was treating her horses, was a black-and-white paint named Dynamite. The very last call I made out to her as a vet, she told me she turned down sixty thousand for him."

"Whew." Jeri whistled again. "That's pricey as far as I'm concerned."

"To me, too. Of course, a high-level dressage rider would consider it cheap. It's all relative." Looking up, I could see the short cul-de-sac where Scott Stone lived approaching.

Jeri followed my gaze. "So is Lindee's ex into barrel racing?"

"Not so I ever noticed. He likes horses in a mild way, I think."

"And he liked her?"

"Well, yes, we suppose so. At one time, anyway." We grinned at each other in mutual understanding, and it struck me how fond

I had grown of this woman over the years. Then we were pulling up a neat concrete driveway to a Spanish-style mansion on a hill. Pseudo Spanish, anyway. As if putting an orange tile roof and white paint on a standardly huge suburban spec house made it look Spanish.

Of course, I live in a seven-hundred-square-foot house, so virtually every other house looks huge to me. Scott Stone's dwelling was probably a mere four thousand or so square feet, considered quite mid-sized in this part of California.

I followed Jeri up the front walk, lined by manicured-looking shrubs with all the character clipped out of them. Jeri marched firmly up to the front door and knocked; I trailed behind her, feeling awkward and wondering what in the world I was doing here. After a minute of empty-sounding quiet, Jeri rang the doorbell. We waited, me standing a few steps behind her.

Scott Stone opened his door and looked at Jeri in mild surprise; his eyes widened in recognition as he spotted me and then, over my shoulder, the sheriff's sedan in the driveway. Jeri extended her hand and Scott smiled politely and took it. I was struck, as I had been before, by his ready charm; he looked for all the world as if he were quite pleased to find a strange woman from the sheriff's department on his doorstep.

"Detective Jeri Ward," Jeri said crisply. "We're here about Lindee Stone."

Scott Stone glanced quickly over his shoulder, as if to check that no one was listening, and then looked back at Jeri with that same relaxed smile. "So what's Lindee up to?" he asked in an easy drawl. "Still chasing cans? Or," his smiling blue eyes narrowed slightly, "something more exciting? Last time the sheriffs showed up on my doorstep, she'd been thrown in jail for bashing her live-in boyfriend over the head with a shovel, and the cops were delivering Jared to me."

At the name, I felt a little shudder go through me. Jared. Her son. I'd completely forgotten about Lindee Stone's little boy.

Jeri looked steadily at Scott. "Lindee Stone is dead."

If Scott Stone was sorry, it didn't show. He looked blank. "She is?" he said, sounding as if he didn't believe it.

After a moment he seemed to take in the reality of Jeri's presence and his face grew more solemn. "How did it happen?"

"A horse went over backward with her," Jeri said. "Gail, here, saw it."

Scott's eyes moved to me. "You saw it?"

"Yes," I agreed. "Happened just after you left her place yesterday. About five o'clock, I'd say."

"You were there yesterday?" Jeri asked Scott.

"Yep. I was there to pick up Jared. This is his weekend to spend with us. He's in my office playing video games," he added. Over his shoulder, I saw movement in the dark hall and wondered if this last was true.

"I didn't see you there," Scott said to me. "Were you treating somebody's horse?"

"No. I'm a stay-at-home mom now." I smiled. "I live next door. I happened to notice you drive out," I lied, not being the least bit willing to explain that I'd been spying on Lindee.

Another motion in the shadows behind Scott. Someone was there.

"So Lindee's actually dead." No mistaking the rising note of exultation in Scott Stone's voice.

I must have winced, wondering if Jared was hearing this. Scott took in our expressions and shrugged one shoulder. "I won't pretend I'm sorry; anyone who knows me could tell you how I feel. Why lie?"

Jeri looked briefly at me and then back at Scott. "I take it you did not get along with your ex-wife."

"You take it right." Scott was about to go on when we both heard the small voice behind him.

"What happened to Mom?"

Scott turned quickly and we all stared at the little boy revealed

behind him. About six or seven, he was somewhat pudgy, with close-cropped light brown hair and blue eyes like his father's. The look he gave the three of us was guarded and wary; his facial expression struck me as sullen.

"My son, Jared," Scott Stone said briefly.

After a moment, Jeri stepped back. "Would you like to take some time to talk to Jared? We'll wait in the driveway." And she turned and walked back down the path. I followed her, noting that the two paint horses that I remembered were still in the small front pasture.

Jeri and I retired behind the car, out of earshot of the house.

"Poor kid," she said quietly.

"Yeah," I said, "poor little kid. I'm sure he overheard Scott say he wasn't sorry Lindee was dead. How's a little boy supposed to deal with that?"

Jeri shook her head.

"I wonder where Tracy is," I said. "I didn't see any sign of her."

"Is Tracy the current wife?"

"Yep. And I think this would be her now."

A shiny gold Mercedes pulled up the driveway and parked in front of the garage. The short, plump, dark-haired woman inside got out of her car and walked in our direction, her face showing mild alarm. Recognizing me, she said, "Gail, hi, what's going on?"

Jeri took charge. "Detective Jeri Ward here," and after introductions were accomplished, repeated the brief information she'd given Scott.

Tracy's pretty face mirrored shock, amazement, and unmistakably, a gleam of the exultation Scott had shown. "She's dead. Really?"

Seeing our expressions, she corrected herself. "Of course. You wouldn't be here otherwise. It's just," she looked helplessly at me, "I can't believe it. I know I shouldn't be saying this, but our whole marriage, she's just loomed over us; she's been such a threat to our happiness; you have no idea." And Tracy burst into tears.

"I take it you didn't care for Lindee Stone." Jeri sounded neutral.

"You can't have any idea what she put us through. Financially, with all her demands for money for more 'child support'; emotionally, making Scott jump through all these hoops just to be with Jared; and the way she's raised that kid—it's a crime. She was evil." Tracy's tear-streaked face gave no doubt that she meant every word. "But I wouldn't wish this on anyone," she added hastily.

I knew exactly how she felt. This was more or less the way I had felt. I wondered how many other people felt the same.

At this moment Scott Stone emerged from his doorway and joined us in the drive. "You heard?" he said to Tracy.

She nodded.

Scott turned to Jeri. "I need to go be with my son. Is there anything else you want to talk to me about?"

"Not at the moment," Jeri confirmed.

"Her death was an accident, right?" Scott's eyes narrowed.

"We don't know for sure. It would seem so."

"How could it not be an accident?" Tracy demanded.

"We have no reason to think her death was anything other than accidental at this time," Jeri said. "There will be an autopsy, naturally. It's routine in cases of unexpected death."

Scott and Tracy both winced at the word "autopsy."

"We'll be in touch," Jeri said. "Go back to your son."

As we climbed into the sheriff's sedan, I said quietly, "They didn't make any effort to hide how they felt."

"No," Jeri agreed.

"The thing is, I'll bet there are a whole lot of people who feel the same way."

"Let's go find out." And Jeri put the car in gear.

Chapter 9

TEN MINUTES LATER we were back at Lindee Stone's training barn; Jeri parked the sheriff's sedan in the crowded barnyard, to the accompaniment of many riveted stares. It appeared that virtually every boarder and training client had shown up at the barn this morning; news travels fast on the horseman's grapevine.

With my hand on the door latch, I looked over at Jeri. "Do you care if I ask a few questions?"

"Unofficially, you can ask anyone anything you want."

"Do you mind, though?"

"No, why would I mind? You could do this on your own, and knowing you, Gail, you will. This way I get to eavesdrop on what you're up to." Jeri grinned at me. "Besides, people will be a lot more forthcoming with you than with me."

"Right," I said, and climbed out of the car.

I'd hardly set both feet on the hard-packed dirt of the barnyard before Kim Salter, who'd been my veterinary client for years, reached my side.

"Gail," she said breathlessly, "have you heard?"

"Heard what?"

"Anything. Why are the sheriffs here?" she added, glancing at Jeri.

"I'm not entirely sure," I said truthfully. "And I don't know much, other than I watched Lindee pull that horse over; it looked very odd. Did you know the horse?"

"Dandy Doc? Not at all. Sheila would know, though."

"Do you have a horse in training here?"

"Did," Kim said. "My young stallion. Remember Skipper?"

"Sure," I said, an image of a blocky buckskin stud with paint patches coming to mind. "He's not in training anymore then?"

"Nope," Kim snapped. "Lindee crippled him. And that's not all. She bred him to her own mares, the ones that are daughters of her stud, without telling me. And without paying me either. I was talking to her about it yesterday, just before she was killed. I told her I'd take her to court if I had to; she owes us those stud fees. My husband, Bill, was really furious. He wanted to kill her. Oh my God." Kim covered her mouth. "What have I said?"

I shook my head. "Don't worry, Kim. There are more than a few other people in the same position. You say Lindee crippled your horse?"

"Just pushed him too hard, like she does all of 'em. He bowed a tendon. He's not coming back from it real well."

A bowed tendon could be a serious injury. I nodded. "And she bred him without your permission? That's bad."

"Damn right it is. Bred him to a dozen of her own mares. She owes, well, owed me and Bill thousands of dollars."

"Whew." I shook my head. "That would make you mad."

"Damn right," Kim said again.

"How well did you know Lindee?" I asked. I noticed that Jeri, still standing quietly near the car and looking off as if studying the crowd, had placed herself where she could hear every word.

"I've known her for ages," Kim said. "But not well. When we put Skipper into training here a year ago was when I really got to know her. Wish I hadn't, now."

"Did she have any health problems?"

"She never said anything about it to me, if she did. We weren't close, that's for sure."

"Who would know, do you think?"

"Maybe her live-in boyfriend."

"Who's he?" I asked.

"Tom Walker. Sitting in that chair over by the barn. Curly dark hair and mustache."

I looked where she was looking. Bingo. The dark-haired man who seemed familiar. "He's her live-in boyfriend?"

"That's right. Was, anyway. They were a funny pair, I always thought. He's only been with her a few months. The previous boyfriend's still hanging around, too."

Kim indicated with her eyes a strongly built guy with short-cropped reddish blond hair, leading a saddled horse towards the arena. I recognized him as one of the unknown males I'd spotted yesterday through the binoculars.

"He still keeps his horse out here," Kim said. "I had the impression he was more or less stalking Lindee, trying to get her back. It was sort of creepy. She kept talking about booting him out of here and having the sheriff's department issue a restraining order. But I notice she never did it."

It looked to me as if Jeri was listening quite intently to all this, though she gave no overt sign.

"Uh-oh," Kim said. "Here comes Sheila. I'll talk to you later, Gail." And she moved off toward the barn.

In another moment tall, blond Sheila Ross stood next to me, watching Kim's retreating form with an annoyed eye.

"She owes the barn money," Sheila said, her already taut jawline seeming to tighten even more. "I guess that's why she's avoiding me."

"She seemed to think Lindee owed her money for breeding her stallion without permission," I pointed out.

"So she says. She can't prove it," Sheila snapped. "But there's no question that Kim owes us several months' worth of training fees that she hasn't paid."

"I see," I said, beginning to. "I imagine she and Lindee were at each other's throats."

"Got it in one," said Sheila. "The trouble is, now that Lindee's gone, guess what? There's no one to pay all the back wages Lindee owes me. So I'm doing my damnedest to collect any outstanding training and boarding bills."

"And these are going straight into your pocket?"

"You bet." Sheila glanced at the apparently oblivious Jeri. "Anybody got any better ideas on how I'm going to get paid what's owed me?"

I shrugged and changed the subject. "Did you know that horse, Dandy Doc, that Lindee was riding when he went over backwards?"

"Sure. I knew him. Rode him lots of times. He's been in training with us over a year."

"Was he prone to rearing?"

"I wouldn't say prone, exactly." Sheila shrugged. "He would rear sometimes. He'd do just about anything to avoid that first turn at times. Rear, run off, try to buck you off. If he was having a bad day."

"What about the third turn?"

"He didn't usually mess up there," Sheila said. "If you got him that far you were mostly all right."

"So what do you think happened to make him rear up and go over backwards right before the third barrel, when everything looked smooth?" I asked her.

"I have no idea. You were right there; you saw it. What happened?"

"It looked like Lindee pulled him over," I said. "And the way she fell, it almost looked like she was already out when she hit the ground. Did she have a heart condition? Epilepsy?"

"Not that I know of," Sheila said. "But then, she might not have told me. We weren't exactly close."

"No?" I asked.

"No," Sheila said, her mouth compressing itself into a thin line.

"Who was she close to?" I asked.

Sheila shrugged. "Her various boyfriends. Roz Richards, maybe." I saw Sheila's gaze drift across the barnyard. Jake Hanson's truck was there again; he was shoeing a small gray horse near the hitching rail. At the horse's head stood a woman with a kinky mane of dark red hair. Roz.

Sheila smiled. I didn't think it was exactly a pleasant smile. But then, nothing about Sheila struck me as particularly pleasant. From her shiny blond veneer to her hard-edged rodeo cowgirl demeanor, Sheila reminded me of no one so much as the late not-much-lamented Lindee. They seemed cut from the same mold. For a second I pondered on why so many of these western horse gals emanated such a tough aura, and then dismissed the thought. The rodeo world was a rough world—to survive as a professional cowgirl required some grit. Sweetness wasn't exactly the desired commodity. Still, it struck me that there was no particular need for the sort of double-dealing nastiness that Lindee had always displayed. I wondered if Sheila was any different.

It didn't look like I was going to find out any time soon. Her jaw clenched in obvious displeasure, Sheila met my eyes briefly and then looked pointedly away. Jerking her chin in the direction of Jake and Roz, she said, "You might try over there, if you want some info."

"Thanks," I said, "I will."

Sheila headed off to the barn without a word or a backward look and Jeri joined me as I started toward Jake and Roz. "Very interesting," she said. "Do you know these two?" And indicated the pair we were approaching.

"Yep. Known them both for years. Jake, the horseshoer, is married to one of our vet techs." I kept my voice down. "He's a big flirt; I think he's a real thorn in her side. Roz has been around the horse business forever. She was a client of mine, back when I was working. She's been with Lindee quite a while, longer than most of her horse-training clients. Most people would have said they were friends."

Jeri nodded and we strolled toward Jake and Roz, who seemed engrossed in an intent conversation, interrupted only when Jake had to pound a few nails. I noticed that just down the hitching rail from the horse being shod was the mostly white paint pony I'd seen yesterday. Once again saddled and bridled, he stood quietly,

his blue eyes half shut, one hind foot cocked in a horse's classic resting pose. I stopped next to him.

"Hey, pony," I said as I stepped up to his left shoulder to stroke him.

The pony looked at me blandly; from his expression I surmised that it would take a lot to disturb that calm demeanor.

Roz was watching me and smiled in my direction. "Hi, Gail. Saying hello to Toby?"

"Is that his name?"

"Yep."

"Whose pony is he?"

"Lindee's, I guess. Or he was." Roz winced. "It was sort of a gray area."

"What do you mean?"

"He belonged to a little girl who boarded him out here. The mom's going through a divorce and they couldn't keep up with the board bills, so Lindee confiscated the pony. She just barred them from the place. It was kind of an ugly scene. Lots of tears from the kid and shouted threats from the mom."

"Oh dear," I said.

Roz shrugged. "You know what it's like when you run a boarding and training stable. There's always trouble of one kind or another."

"I suppose," I said. "Lindee seemed to have more trouble than most."

Roz shrugged again. I studied her. I had known this woman for many years, in the way in which one knows a veterinary client. Which is to say that though we were quite familiar with one another and always cordial, we really didn't know each other at all. As I viewed the expertly made-up face framed by a ruff of waving auburn curls, I realized that this sophisticated mask was about as deep as my knowledge of Roz Richards went.

"Did Lindee have any health problems that you knew of?" I asked, forging ahead.

Roz turned to face me directly, still holding the gray horse's lead rope, but ignoring both horse and shoer for the moment. "What do you mean?" she asked.

"Heart problems, epilepsy?"

"Why?"

"Because I watched her pull that horse over yesterday, and it looked to me like she was unconscious when she hit the ground. I was just wondering."

Roz glanced from me to Jeri. "You were wondering? Is this an investigation?" she asked us both.

"Of a sort," Jeri answered smoothly. "As far as we know, this is an accidental death. It's the same as if we have a single-car accident, where the car goes off the road with no obvious cause. We always check for some kind of underlying medical reason. Which is what, in effect, I'm doing here. As Gail knows everybody, and I don't, I've been observing the responses she gets, but if you'd rather, I'll ask the questions."

Roz looked from Jeri to me and then back to Jeri. "I never heard of Lindee having any health problems," she said slowly. "She never mentioned a heart condition or epilepsy or anything like that to me. And I've known her awhile."

I noticed that for someone who had "known her awhile" and was supposedly a friend, Roz looked completely unmoved by Lindee's recent demise. No tear streaks marred her foundation; her mascara and eyeliner were sharp and fresh, the big greenish eyes singularly bright and without any tinge of red.

"Any known drug habits? Was she a drinker?" Jeri asked the questions quietly; I noticed Jake Hanson set the gray horse's hoof down and look in Jeri's direction.

Roz stared at Jeri.

"This is a routine line of questioning," Jeri explained, "it's not particular to this woman."

"So you're not suggesting you think she had a problem?"

"No," Jeri said. "All I'm doing is trying to determine if there is

some possible underlying cause. Gail, here, is my witness; she saw the wreck. Since she thinks Lindee Stone may have passed out or blacked out, and all the evidence is that Lindee was a very experienced horse trainer who was unlikely to have been caught unaware by that particular horse, I'm checking into the possibilities."

Roz nodded slowly. "You're right about the horse," she said. "Dandy could be a pain, but I wouldn't have said he was dangerous. Now if it had been Sox..." She chuckled, but the sound was not humorous.

"Sox?" Jeri asked.

"Bay horse with a bald face and high white socks," Roz explained. "Next one Jake has to shoe. He's a damn good barrel horse, but he can be lethal. He frapped Lindee on the ground just last week; she hit pretty hard, too. He's sneaky. He waited until she wasn't paying attention; she was climbing on him and talking to me at the same time and he just jumped out from under her. She had a headache the rest of the day from hitting her head on the ground."

"And this was last week?" Jeri asked.

"Yeah, you have to watch out for Sox. He'll do just about anything to get you. Lindee trained him; she knew him, but he could still catch her."

"Do you think she had a concussion?" Jeri asked.

"I don't know. I guess it's possible. She certainly didn't go to the doctor. Lindee was one tough gal." Roz said this without emphasis, and again, without any particular sign of grief. "As for the drugs and drinking, I've known Lindee to indulge," I noticed Roz didn't say in what, "but she was straight yesterday afternoon, as far as I could tell. And I was talking to her less than an hour before the wreck."

"She was drinking something," I said, remembering the glass of brown liquid on the table in front of Lindee.

"Iced tea," Roz said dismissively. "She always drank iced tea when she was training. Never anything else."

"The guy with her was drinking something, too," I pointed out, "and I had the distinct impression it was not iced tea."

"Tom." Roz said the name equally dismissively. "He's a musician." As if that explained it.

"He is, or was, her boyfriend?" I asked.

"He lives here." The dismissive tone was more marked than ever. I wondered what the deal was with the mysterious Tom.

Roz's attention seemed to have gone back to the horse she was holding; I got the impression that she was willing Jeri and me away; perhaps she felt that she'd been questioned enough. I glanced over at the table and chairs near the entrance to the barn. Tom Walker sat there alone and, despite the fact that it could only have been ten in the morning, he was sipping gently at what looked like whiskey to me.

Catching Jeri's eye, I jerked my chin in Tom's direction. She nodded and we moved off together—a pair of sharks trolling for unsuspecting fishy prey. I grinned to myself at the unlikely metaphor; I was hardly very shark-like in my current incarnation.

Tom Walker looked altogether unperturbed at out approach. If we were predators to his prey, he didn't seem to know it. Raising his glass in a lackadaisical way, he greeted the two of us with the slightest of amused smiles. I was certain I could smell the distinct odor of single malt Scotch.

"Tom Walker?" Jeri asked the question.

"That's me. And you are?"

"Detective Jeri Ward of the Santa Cruz County Sheriff's Department."

"I'm Gail McCarthy," I added. "I'm your neighbor."

"Oh yes. Dr. Gail McCarthy, the horse vet. Lindee's mentioned you."

I didn't know how to reply to this, so I said nothing. Close up, Tom Walker was even more intriguing. His dark hair, somewhere between curly and wavy, sprang off his brow in an attractive way and his equally dark eyes were both humorous and enigmatic. He had a somewhat stern mouth and a strong, cleft chin. I couldn't rid myself of the notion that I'd seen him before, but I couldn't imagine where.

"Haven't I met you before? You look familiar." The words just popped out of my mouth; I hadn't meant to speak them aloud.

"Do you like Celtic music?" His reply was completely unexpected, and suddenly I got it.

"You're the piper," I said slowly.

He smiled. "Got it in one."

Blue and I had gone to a St. Patrick's Day party, pre-Mac, and the band had been lively and Celtic. Much green beer and Scotch whisky had been imbibed and plenty of dancing had ensued. Both Blue and I had commented on the skill of the piper; true to his Scottish heritage, Blue liked bagpipe music. This handsome, dark-haired man was that piper.

Once again, before I considered them, words leapt out of me. "How in the world did you meet Lindee?"

"At a bar, of course. Same way I met every other girlfriend I ever had." He looked both amused and resigned.

I shook my head in puzzlement. "If you don't mind my asking, what drew you guys together? I can't picture Lindee as a fan of bagpipe music."

At this he actually laughed. "She wasn't. I'm not sure what drew her to me." His eyes twinkled up at us. "Modesty forbids me to speculate."

I couldn't help returning his smile. Damn, he was a cute man. No wonder Lindee had wanted him.

"As for me," he went on, "well, she had a house."

"A house?" I repeated blankly.

"Yes." He pointed over his left shoulder. "That house."

"You wanted that house?" I must have sounded as puzzled as I felt. Lindee's ordinary ranch-style house was anything but attractive in my eyes.

He grinned again. "I'm a musician. The day before I met Lindee at the Corner Pocket Bar, I broke up with my last girlfriend. What do you call a musician who breaks up with his girlfriend?"

Jeri and I looked at each other.

Tom Walker watched us, clearly quite comfortable. "Homeless," he said, after a moment. Swirling the liquid in his glass, he took a gentle sip.

"Oh," I said. "You don't mean you wanted that house, you just wanted a house."

"That's right. Somewhere to live. And she had a place and seemed willing."

I must have looked shocked; the man's eyes held more of an ironic twinkle than ever.

"Cynical, you're thinking. Lindee didn't seem to mind. I think her motives for keeping me around were similar to my motives for staying."

"What do you mean?" I asked him.

"Convenience. I was convenient for her in a number of ways, some of which I won't name."

"I see." Jeri's voice was even more detached than usual. I wondered what the heck she made of Tom Walker.

"So what will you do now?" I asked the man.

"Now that Lindee's dead, you mean?"

"That's right." I noticed that Tom Walker, like every other person I'd spoken to, seemed singularly unmoved by Lindee's death.

"Keep living here until somebody boots me out, I guess. It's a unique situation." And damned if he didn't smile and take another sip.

I couldn't help myself. "Aren't you even sorry that she's dead? You were her boyfriend, after all."

Tom Walker met my eyes. "We weren't exactly a romance," he said quietly.

"I see. Do you happen to know if she had a heart condition, epilepsy, or some other sort of disorder that would cause her to black out?" Jeri asked him.

"I have no idea. She never blacked out around me. Never mentioned any sort of medical problem."

"Did she drink or take drugs?"

Tom Walker narrowed his eyes. It struck me he was nothing if not quick. "Yes to both," he said, "but she seemed completely straight yesterday afternoon. I spoke to her less than an hour before the horse went over with her; she appeared absolutely normal."

"Right," Jeri said. She glanced at me, then back at Tom Walker. "Nice to meet you," she said. "We'll be in touch."

I smiled vaguely, unsure what to say.

"Likewise." And he raised his glass once more.

As Jeri and I turned simultaneously and began walking away, it hit me. A sudden gush of emotion, the sense of something big squeezing my heart. I missed Mac. I missed my baby.

In that moment my interest in these people, in the logistics surrounding Lindee Stone's death, vanished like mist in the sunshine. "I need to go home," I told Jeri.

"What?" Jeri sounded startled, as clearly she might be.

"I need to check on Mac." I knew I suddenly sounded like an unreasonably anxious mama; I didn't care. What I was, I was. "I'll walk home," I said quickly. "You keep on doing what you need to do."

And in another minute Jeri, as well as the barn and all its personnel, were receding behind my back as I hiked down the driveway and out the gate, my mind set on a single goal. I was going home.

Chapter 10

FIVE MINUTES LATER I walked in my own front door. With a sigh of relief, I heard the giggles spilling out the open bedroom door—Mac was definitely having fun. Quietly I sneaked down the hall and peered around the corner of the doorway.

Mac was sitting in the middle of the unmade bed, a wide-eyed smile on his face. Grinning back at him, Blue held a pillow up: "One, two, three!"—and on three Papa lofted the pillow right at Mac, knocking him flat on his back, to accompanying squeals of delight.

I cleared my throat. "Is that what you call playing fair?" I said, as Blue turned to meet my eyes. "He isn't exactly big enough to throw the pillow back."

"But he likes it." Blue gestured at the giggling baby, lying on his back on the bed.

"I see that."

Mac had spotted me and raised his arms in my direction. "Mama." Or at least, something close to that sound burbled out of his mouth.

I picked him up, and felt the little hands instantly fumbling with my T-shirt. "Time for a snack, huh?" I said, and sat down on the bed next to Blue.

Filling my husband in on my morning's adventures as I nursed Mac, I could feel myself settling into the quiet rhythms of family life, the disturbing ripples surrounding Lindee Stone's death dissipating, leaving the surface of my mind still and clear. What did it really matter if seemingly dozens of people hated Lindee, and

her wreck had looked oddly unnatural? It wasn't my business; my business was here with Mac and Blue. Not to mention, the woman was dead; no power on earth would bring her back or help her now. On top of which, a snide little part of my mind added, you don't want her back. You're better off now that she's dead. I wrinkled my nose at the thought. I had to admit that it was true, and I didn't feel good about it.

"Now that you're back," Blue said, "I need to do a little weeding in the vegetable garden."

"Fine," I said. "I'll bring Mac out when we're done. Maybe we'll ride Plumber."

And so the day passed in a pleasant, normal fashion. Blue worked in the garden, weeding and tidying. I caught and saddled Plumber and took Mac for a ride around the property, smiling at the wide grin on his little face as he reached down to touch Plumber's mane. The chickens were released from their coop and were repeatedly shooed out of the vegetable garden by Blue, who didn't like them scratching up his planting beds. Roey and Freckles trotted at our heels, lying down in the shade of the birdbath when they got tired, seeming content to watch Blue work. Business as usual—a quiet, relaxing Saturday at home. Until the phone rang, late that afternoon.

"This is Nina Harvey." The voice on the other end was as level and pragmatic as ever. "I'm sorry to bother you, Gail, but I'm taking care of the whole barn right now, since Sheila took off. Tess Alexander's mare is colicking. The vet on call at your practice has two other emergencies before she can get to me. I can't reach Tess at all. So since you're right next door, I just wondered…" Nina's voice hesitated for the first time.

"Of course," I said. "I'll be right down."

Explaining the situation to Blue, I asked him, "Do you mind watching Mac while I check on this horse?"

"Of course not," Blue grinned. "Gone are the days when I wanted to sell him to the gypsies when you went out."

I smiled back. Blue and I joked about it now, but I well remembered those early days of fatherhood, when Blue, sick of sleepless nights and not blessed with a mother's hormone-generated bond to her infant, had told me, more than half seriously, "I'm not sure if I really want this baby. A lot of the time I wish I could sell him to the gypsies."

I'd tried to comfort and reassure Blue, certain in my intuition that his love for Mac would bloom in its proper time, and sure enough, by the time our child was six months old and able to smile winningly into his papa's eyes, Blue was as enamored of Mac as I was.

"It's just a slower attachment curve for dads," I said now. "You guys don't have all those hormones convincing you that you really love this little pink, helpless, wiggling thing."

"Yeah, the little pink worm stage." Blue smiled and shook his head. "I have to say I'm glad that's over."

I laughed. "You're a good papa," I said. "The best. Even if you didn't care for the newborn stage as much as I did. Try not to knock Mac out while I'm gone, okay? No more pillow fights."

"Right," Blue said.

"I'll be back soon."

"Take your time, Stormy. We'll be fine."

Trudging down to the barn I collected my emergency veterinary kit (kept primarily for my own use) and picked up my stethoscope, then walked on down the drive. A mellow summer afternoon was just edging toward evening. Not a trace of fog in the air and a sweet, deep gold in the light promised it would soon be a beautiful moment for porch sitting. I resolved to get back home as fast as I could; maybe I could convince Blue to make margaritas and barbecue steaks.

The crowd seemed to have abated somewhat at the training stable—perhaps most folks had plans for Saturday night. Jake's truck was gone and I saw no sign of Sheila or Roz. Tom Walker was nowhere in evidence. I could see a couple of bobbing female heads

trotting horses in the main arena; they appeared to be teenagers. Nina Harvey was standing in the open archway of the barn door, clearly waiting for me.

"She's this way, Gail." Nina turned and led the way down the barn aisle, which was neatly raked and sprinkled, I noticed, no doubt by the woman ahead of me.

Nina stopped at a box stall halfway down the aisle and gestured at the barred window on the sliding doors. I glanced in and saw the sorrel-and-white paint mare lying flat on her side, the focused, inward look in her eyes indicative of a horse in pain. There were light sweat marks on her shoulder, neck, and flanks. It looked like Bella was colicking, just as Nina had said.

Colic is relatively common in horses, and by far the likeliest cause of equine death. A horse's digestive system is constructed such that he can't throw up, thus any sort of belly ache, or colic, can result in a ruptured gut, which is fatal. All experienced horsemen were constantly watchful for colic, and Nina would certainly be no exception.

"Let's get her up so I can check her vital signs," I said.

"Right." Nina walked into the stall, carrying the halter that had been hanging on a peg by the door. "Come on, Bella, get up." And she clucked encouragingly to the mare.

Bella lifted her head, then struggled up on to her chest. Nina clucked again and the mare lunged up to her feet, shaking her head wearily.

"Has she been rolling or thrashing at all?" I asked.

"No. Just lying quietly. I was getting the feed cart ready and I saw her lying here. I knew she wasn't right. I tried to reach Tess and couldn't get her, so I called the vet right away, and then when the answering service said she couldn't be here for a couple of hours, I called you."

Nina led the mare out of the stall and into the barn aisle. I began the process of checking her vital signs, using the stethoscope to monitor respiration and heart rate, and listen for gut sounds.

"Her pulse and respiration are a little elevated, not bad," I told Nina, "and she's got some gut sounds, not a lot, but some."

Taking hold of the mare's muzzle, I lifted her lips away from her teeth. "Gum color's okay," I said. "She's not in any deep trouble here."

I gave the horse a gentle pat on the neck as I studied her. She looked unhappy, but she wasn't agitated. There was only the slightest trace of sweat. Judging by the gut sounds, her intestines were functioning relatively normally.

"I think it's pretty minor," I said slowly. "Has she ever colicked before? I don't remember ever treating her for this."

"I can't really remember." Nina sounded reflective. "We've got so many horses here. If she has, it hasn't been often. It isn't a pattern or anything."

"Good," I said. "I think we can give her a little painkiller and just keep an eye on her. I've got some banamine with me; I'll give her ten cc's IV and hopefully she'll come out of it."

As I spoke I was filling the syringe from the vial in my vet kit. Rolling my fingers against the underside of the mare's neck, I felt for the jugular vein. Bingo. Slipping the needle in, I smiled as the quick gush of blood flowed into the syringe. I hadn't lost the touch.

Injecting the medication into the mare's vein, I pulled the needle out and turned back to Nina. "I don't have any equipment here to oil her up. You'd have to get whoever's on call for that." Tubing mineral oil down a horse's esophagus in order to move any obstructions quickly through the gut was a time-honored remedy for colic.

"Do you think that's necessary?" Nina asked.

"Not at this point, no. You'll need to check on this mare every couple of hours. If she starts to get painful again, you'll have to have the on-call vet out. I'll give you another syringe of banamine that you can give her if need be."

"I don't know how to give IV shots," Nina pointed out.

"That's okay. You can put the shot in the muscle. It just takes a little longer to take effect, maybe twenty minutes instead of right away. You know how to give that sort of shot, right?"

Nina nodded. I wasn't surprised. Almost all horsemen were comfortable with giving intramuscular shots; it didn't take any special skill. Just plink the needle into the muscle and inject the fluid.

I filled a syringe with another ten cc's of banamine and handed it to Nina. "In case you need it," I said.

Nina took the syringe and led the mare, who already looked a good deal more comfortable, back into the stall.

"There you go, Bella." Nina patted the horse on the neck as she turned her loose.

"Don't feed her much this evening," I cautioned, "maybe a quarter of her usual feeding."

"Right," Nina said, "I hope she'll be okay. She's a good girl. And you know Tess. She'll have a fit about this." Nina rolled her eyes.

"Bella's a real sweet horse," I said. "Tess can be difficult."

"She's a pain," Nina agreed. "But Bella is one of the nicest horses in the barn. Not like him." And she gestured at Bella's next-door neighbor.

I glanced through the barred window at the inmate, a handsome bay gelding with high white socks and a bald face, who pinned his ears and glared at me.

"Meet Sox," Nina said grimly. "Delightful creature that he is. I wouldn't advise going in there with him unless you're carrying a pitchfork or a shovel."

"What would he do?" I asked.

"Spin around and try to kick you," Nina said. "That's his favorite trick. He'll do it when you're riding him, too. Sort of spin out from under you and kick you while you're flying off of him. He got Lindee the other day. He didn't manage to kick her, but he sure dropped her on the ground."

I looked at Nina curiously. She spoke of Lindee as if she were still alive; like most people, it seemed, she wasn't showing much in the way of grief.

"What makes him so ornery?" I said, glancing back at the horse.

"Lindee," Nina answered promptly. "She raised him and trained him. Old Sox, here, was a tough nut to crack, but Lindee's tougher. She made a good barrel horse out of him, but at a price. Sox is meaner than she is. Was." Nina corrected herself hastily, seeing, I was sure, my slightly shocked expression.

"I know, she's dead." Nina sighed. "The truth is still the truth."

"Why did you work for her then?"

Nina began to stroll down the aisle toward the shed at the end that sheltered hay and grain. I walked by her side, curious to hear what she would say.

"Why did I work for her? To begin with, I suppose, I was a star-struck teenage girl. It was my dream to work for the famous Lindee Stone. I grew up in Nebraska, and I always wanted to be a barrel racer. I read everything I could about the good ones; Lindee was my hero. I didn't have a horse; I didn't even know how to ride; I grew up in a suburb and my folks didn't have enough money for horses or riding lessons. But the minute I turned eighteen, I headed out to California in my Volkswagen van, determined to find Lindee Stone and ask for a job."

"Wow," I said, impressed. "And she gave you one?"

"Yeah," Nina grinned. "How could she refuse? There I was on her doorstep, telling her I'd do anything, muck out stalls, whatever, and she didn't have to pay me. I'd do it for room and board."

"Wow," I said again.

"If you knew Lindee, you know she went through barn help so fast it was unbelievable. She'd lost the last one a week before I came. She took me on instantly, gave me the travel trailer, which was filthy, and paid me one hundred dollars a week—enough for food, sort of."

"And you stayed?"

"Well, yeah. I really had nowhere to go. I was broke, and the van gave up shortly after I got out here; I didn't know another soul in California, and my family back in Nebraska aren't speaking to me. They didn't fancy my running away to California much. They don't even really know where I am."

"I see."

Nina sounded relatively cheerful about all this. As we reached the feed room, she gestured at a small side door. "Do you want a cup of tea? I've got a spot back here that's kind of nice."

Curious as to what she meant, I nodded. "Sure. Thanks." And followed her out the door and around the corner of the hay shed.

Here, as I had surmised, sat the small silver Airstream trailer where Nina lived. Right in front of the door was a little pergola, somewhat crooked and precarious in appearance, that looked as though it had been made from odds and ends—fence posts and tree limbs, mostly—with a grapevine trained over it. The bright green leaves flickered lazily over the tiny space, maybe five by five, floored in gravel, which sheltered two folding chairs, a small collapsible table, and a couple of terra-cotta pots with brilliantly red flowered geraniums spilling out of them. The effect was somehow that of a French courtyard in miniature.

"Have a seat," Nina said. "I'll be right out with the tea."

"Thanks. This is nice." I settled myself in a chair and looked around. The grapevine made graceful shadow patterns on the wall of the hay shed, which was just about all there was in the way of a view. This small spot was amazingly private, given the crowded, busy environment of the training barn. Craning my head over my right shoulder, I could just glimpse Lindee's gray-and-white ranch-style house, not twenty feet away across a strip of shaggy lawn. But the house wall that faced Nina's tiny courtyard was unwindowed, increasing the sense of seclusion and privacy.

Nina appeared with two steaming cups; I accepted one and declined milk and sugar. Lowering her body into the chair next to me, Nina sighed. "It feels good to sit down. Though I've only got

five minutes. The horses still need to be fed, and that's an hour's worth of work."

"You do all the work?" I asked, sipping tea.

"All of it. Night and morning feeding, all the stall and pen cleaning, as well as keeping the barn and barnyard neat and working up the arena when it needs it. Not to mention weed-whacking as necessary."

"That's a lot to do."

"It's a full-time job."

"What will you do now?" I asked curiously.

"Now that Lindee's dead, you mean? I don't know. She was a complete bitch to work for, never stopped screaming, it seemed like. At me, or whatever assistants she had, at the clients...you name it. And she was hell on the horses. But this feels like the only life I know, anymore. I've been with her three years.

"Right now I'm just taking care of the horses because it needs doing. Sheila says she'll make sure I get my hundred dollars a week." Nina shrugged. "We'll see."

"Will Sheila stay on as trainer?"

"I have no idea." Nina shook her head. "This place belonged to Lindee, I think; I don't know what will happen to it now. Sheila's taking the tack that she's the trainer, sure, she's competing in Lindee's place at Salinas, but I don't know how many of the clients will stick with her. She's not the name that Lindee was."

"At Salinas? You mean the Salinas Rodeo?" I asked, sipping a little more tea.

"That's right. Lindee thought she had a real chance to win there this year. On Sox," Nina added.

"The grouchy horse?"

"That's right. Sox is mean, but he's fast. Sheila's going to ride him. Good luck to her."

"Anybody else going to show there?"

"Well, Roz is. I don't know of anyone else from this barn. Roz's little gray horse, that's Frankie, and Sox are the only two we have

here right now that are really in that league. Lindee sold Dynamite a while ago. I think she needed money."

"I saw Jake shoeing the gray horse this morning," I said.

Nina smiled. "Oh yes. The show must go on. He shod Frankie and Sox; the Salinas Rodeo is just two weeks away. Didn't matter that Lindee bought the farm yesterday; nobody wanted to cancel the shoer."

I shook my head. "No one seems sorry Lindee's dead."

Nina sighed. "I'm afraid that's more or less true. What can I say? You reap what you sow. She made a lot of enemies. Maybe Jared misses her. But she sure didn't seem to have much time for him."

Taking a last swallow of her tea, Nina stood up. "I'm sorry. I've got to go. Horses need to be fed."

"I need to get home, anyway. Thanks for the tea."

"No problem. What about the vet bill?"

"Don't worry about it," I said, thinking that Jim, my partner at Santa Cruz Equine Practice, would not thank me for this. "Just call the practice, not me, if she's worse tonight. That banamine I gave her should wear off in six to eight hours."

"Will do," Nina said.

As we walked back toward the hay shed, I could see a small pen that I hadn't noticed earlier, crammed up against the back wall. Measuring about ten by ten, with no shelter of any sort, and no gate, just a casual loop of baling wire securing the panels, it contained a five-gallon bucket of water and the mostly white pinto pony I'd noticed earlier.

"Toby," I said, and moved in his direction.

"Yeah, poor little Toby." Nina followed me and we both stared at the pony.

About thirteen hands high, bigger than the average Shetland-type pony, but definitely smaller than a horse, Toby the pony was coarsely made, with a plain head, and looked exactly the sort of animal that would have worked the pits in Wales. Virtually an albino, with the exception of a couple of sorrel patches, one right between

his ears, his pink-rimmed blue eyes did nothing to improve his overall homeliness.

Nina shook her head. "Lindee didn't want to waste any space on him, since no one pays for his keep. This really isn't an adequate place to keep anything, even a pony."

I couldn't help but agree with her. Small as he was, the pony barely had room to turn around. And no shelter at all from the sun or rain.

"He seems like a good little guy." Toby stuck his nose between the bars and snuffled the hand I stretched out to him.

"He's a great kid's pony. Bomb proof. Lindee said he was for Jared, but Jared isn't interested. Sheila's making plenty of money using him for lessons; I don't know why they figure he doesn't deserve a proper stall or pen. He does more than his fair share of work."

I gave the pony a final pat, feeling sad. Something about the small, stoic creature appealed to me, though I'd never owned a pony in my life. I noticed that he had a faint sorrel splotch right on the end of his muzzle, which was still thrust hopefully between the bars of his pen, as if in expectation that he would be given a carrot or other treat. Perhaps the little girl who had once owned him had fed him carrots.

"Who will end up with Toby?" I asked as Nina and I walked on.

"Who knows." Nina shrugged. "Lindee didn't really own him; she just confiscated him from the woman who had him here and couldn't pay the board bill. And that gal's moved to the East Coast, I hear; she won't be coming back for Toby. He really doesn't belong to anyone. Want a pony?" And Nina looked at me quizzically.

"Me?" I stopped, startled, and looked back over my shoulder at Toby, who was still watching us hopefully, his head and neck thrust out between the bars of his small pen. "What would I do with him?"

"Lead your little boy around on him." Nina shrugged again. "Sheila would have a fit, though. She gives lots of kids riding lessons on him."

I nodded as we walked into the big barn through the door by the hay shed. "I really don't need any more critters."

Bella looked quite normal as we walked by her stall, I was relieved to see.

"Thanks again, Gail," Nina said.

"No problem. I'll walk down again tomorrow and see how she's doing. See you later." And I was once again exiting Lindee Stone's barn, this time with steaks and margaritas on my mind, and no premonition at all that the troubles here were far from over.

Chapter 11

SUNDAY MORNING PASSED without incident, if you didn't count my chasing off a coyote who was trying to make a meal out of Rob Roy. Fortunately, all chickens escaped unscathed. In the afternoon, once again leaving Mac with his father, I set off down the hill to see how Bella was doing.

Lots of people about today. Jake Hanson's truck was here again; also, I noted, the truck from our veterinary practice. Hoping that this didn't mean Bella was worse, I moved toward the small group beside the truck. Rita was holding a blue roan gelding while Lucy Conners, the vet who had replaced me, stitched up a cut on his left front leg. Sheila Ross and Roz stood nearby, watching Lucy.

Roz greeted me with a wide smile. "Hi, Gail."

Everyone murmured greetings, except Lucy, who was absorbed in her work. I waited quietly, not wanting to disturb her. I noticed that the stocky man with reddish hair that Kim had referred to as Lindee's ex-boyfriend was also watching Lucy work. At that point, my chances of noticing anything else vanished, as Tess Alexander was upon me.

"Thank you so much, Gail. Nina told me what happened, I can't thank you enough, she's fine now, but my God, what if you weren't there…" Tess's breathy, excited voice ranted on and on; her blue eyes seemed stretched wider than ever as she talked, staring intently into my face the whole time.

The man with the close-cropped red hair took a step in our direction and Tess turned to him. "Oh, Robert, I'm so glad you're here; you know so much about horses, would you just have a quick

look at Bella? I think she could use some exercise, but I don't want
to stress her."

Robert seemed to accede to this request, at least he moved off
with Tess in the direction of the barn.

"Thank God," Sheila Ross said in an audible whisper. "She's such
a pain. I can't even bring myself to try and collect all the board she
owes; then I'd have to listen to her."

Unkind as the statement was, I found I understood the senti-
ment perfectly. Tess was one of those people I tended to think of as
a wreck waiting to happen. Something was always wrong, noth-
ing was ever right. Watching her trim figure and blond hair move
off toward the barn, Robert by her side, I wondered what exactly
made Tess so difficult. It just seemed to be an atmosphere she car-
ried with her, a sense of frantic urgency and strain that accompa-
nied her through the most mundane of conversations.

"Guess she thinks she can get old Robert back now that Lindee's
gone," Roz said, with a slight chuckle.

"Maybe she can," Sheila rebutted, "and good luck to her. Who in
their right mind would want Robert, anyway?"

Silence greeted this remark.

"So Robert was Lindee's boyfriend?" I asked the group at large.

"Used to be," Roz said. "Before that he was Tess's boyfriend.
Lindee took him away from Tess, or so Tess thought."

Sheila curled her lip. "I think Lindee was damn sorry she ever
let him move in with her. They fought constantly. Robert likes to be
the boss, you know, and Lindee wasn't likely to put up with that.
After awhile he tried to beat up on her; she had to hit him over the
head with a shovel and knock him out, one time."

"I heard about that," I said. "So that was Robert."

"Yep," Roz agreed. "Lindee threw him out after that and took up
with Tom. But Robert kept hanging around, trying to get Lindee
back. And Tess kept hanging around trying to get Robert back. It
was all pretty pathetic."

"Looks like Robert and Tess might have a happy little ending,

now that Lindee's been removed from the scene." The sneer in Sheila's voice was plain. "If ending up with Robert Miller, or for that matter, Tess, can be considered a happy ending."

There didn't seem to be much to say in response to this last statement, and a brief reflective quiet fell on our little group.

Lucy put the last stitch in the gelding's forearm, looked up, met my eyes, and smiled. "Hi, Gail. Good to see you. How's Mac?"

"Doing well. Currently with his father. How are you?"

"Pretty well, all things considered." Lucy smiled at me again; I was struck as I always was at her intricate quality of combined beauty and strength. Slim, dark, with crinkly black hair and green-brown eyes, Lucy Conners was as lovely to look at as I could imagine a woman being, and tough, smart, and a fine horse vet to boot. What more could you ask?

I was aware that I felt mildly jealous upon seeing Lucy; I always felt this way. I was also aware of how much I liked and respected her. It was, all in all, an odd combination of feelings to deal with. I had helped hire Lucy, I was glad she was here, seeing as I wanted to be at home, and yet, this was my job she was doing, my truck she was driving. I still couldn't quite get used to it.

Turning to Rita, I said, "You and Jake are working in the same place today, for once."

Rita smiled back, a little sourly. "What a sweet coincidence, huh? Maybe we should have a rendezvous."

Sheila and Roz looked at each other. I thought there were a lot of unspoken comments in that look. I only wished I knew what they meant.

Rita shrugged. "Jake's busy. I'm busy." She smiled a white flash of a smile at me. "We'll have plenty of time at home tonight."

Again, I saw Roz and Sheila lock eyes. Something going on here; what, I didn't know.

"So is Tuffy done?" Roz asked Lucy.

"All stitched up," Lucy agreed.

"I can't imagine how he did this, in a pipe corral." Roz shook

her head. "I swear, if I locked my horses in padded cells, they'd find a way to hang themselves." And Roz led the gelding off to a chorus of muttered agreement. We were all familiar with the way that horses, kept in what looked like perfectly safe pens, could manage to injure themselves, sometimes quite severely.

Sheila sighed. "No use putting it off, I guess. I'd better go get Sox."

"Sox?" I queried. "The nasty one?"

"Yeah, him. The Salinas Rodeo's only a couple of weeks away. We'd better get used to each other. I'm going to compete on him." She shook her head. "This horse training business isn't all it's cracked up to be. I wanted to do this all my life and now I'm doing it and guess what? A lot of the time it's not much fun. Collecting money from folks who don't want to pay what they owe and trying to survive aboard that damn Sox is not fun for sure. But here I am. I don't know how to quit." Glancing at Lucy, she added, "Could you come look at one more thing before you go? This sorrel horse has an odd swelling in his right rear fetlock."

Lucy followed Sheila; I saw Rita drift off towards Jake, who was bent over the left front foot of a paint gelding tied to the hitching rail in front of the barn.

I gave brief thought to bailing out of here myself, but instead went in search of Nina. It took awhile to find her. I walked through the big barn and then along the shed row outside. No Nina. She wasn't in her little courtyard, either. I stopped to give Toby the pony a pat and then stepped back into the big barn via the small side door near the feed room. Hearing the distinctive "whump" of a shovelful of manure landing in a wheelbarrow, I stopped outside the first stall past the feed room and looked in. Inside, Nina's form was bent over, shovel in hands, hard at work.

"Hey, Nina," I said.

She looked up, shaking the fringe of curly hair out of her eyes. "Oh, hi, Gail."

"Bella's okay, I hear," I said.

"Yeah, she's fine." Nina swiped her hand across her forehead.

"Did you have to give her the second dose of banamine?"

"No, she never looked back."

"Good." Without really meaning to, I glanced over my shoulder in the direction of Toby's pen, seeing the small, morose, white shape crowded up against the bars.

Nina followed my gaze. "He is a real good kid's pony," she said.

"Right." I jerked my eyes away. "I just wanted to check on Bella. Tess seems to be dealing with her."

"Uh-huh. I'm hiding so I don't have to talk to her anymore. I gave her the relevant info. You know how she is."

"Yep." I knew. Tess would talk your ears off.

Nina shook her head. "Yeah, and I've got a lot of work to get through this morning, and it's been one thing after another. Just a minute ago, that crazy Sox had some kind of fit, banging around in his stall. He's an idiot."

"Right. Well, I'll let you get back to work. Call me if you need me."

I turned back toward the barn, which seemed full of people. Roz was coming out of a stall; Tess and Robert were standing in front of another stall, locked in intense conversation; Rita was following Jake out the front doorway, and Sheila was leading a bay gelding that I recognized as Sox out of yet another stall.

Sox was already saddled; perhaps he had been left saddled and tied in his stall; it was a routine ploy with a difficult horse. He switched his tail and pinned his ears, as if aggravated, as Sheila led him out into the barnyard.

I walked out the barn doorway; Tom Walker was ensconced in his chair, customary glass in hand. I smiled and nodded; he raised the glass. I looked back at Sheila.

She was regarding Sox dubiously as he shook his head and stomped his front feet at her. After a minute's hesitation, she led him off toward the arena. I followed, curious to see what Sox was like when one actually mounted him.

I didn't envy Sheila as she led Sox through the arena gate, checked his cinch, and flipped the reins over his head, being careful to stay out of range of his teeth. The horse was becoming increasingly agitated, switching his tail and stomping his feet repeatedly.

Sheila put her left foot in the stirrup, took ahold of the horn, and started to swing herself up and onto his back. Sox snorted, his head came up and he sprung back and sideways, all in one motion. I gasped. Sheila was clearly prepared for this; her grip on the horn kept her attached to the saddle. But even as his feet hit the ground, Sox staggered, lurched, and lunged sideways again, then put his head down and bucked.

Sheila's face registered surprise and fear; she was still aboard, but barely, her right leg swinging free, her balance tenuous. Sox was running backwards now, and then half leapt, half fell to the right. Sheila lost her grip; as her body hurtled past, Sox kicked out with both hind feet; I heard the hard crack as one steel-shod hoof connected with Sheila's head.

A thud as Sheila's body hit the ground; I could see Sox collapsing nearby, still kicking and thrashing.

Even as I ran toward Sheila's ominously still figure, I couldn't avoid the thought. Only two days ago, not fifty feet from this spot, I had stared at Lindee Stone's body, thrown from the back of a horse, never to move again. Was this place cursed? And if so, by whom?

Chapter 12

SHEILA WAS BREATHING, at least. And she had a pulse. I could hear people approaching behind me as I sat by her side in the sand of the arena.

"Call nine-one-one," I said over my shoulder to the milling voices.

"I just did. They're on the way." It sounded like Roz.

I held Sheila's hand in mine, my fingers tracing the steady beat of the pulse in her wrist.

"What happened?" Roz again.

In the corner of my eye, I could see Sox, flat on the ground, looking as if he were as out-cold as Sheila. Jake Hanson was at the horse's head, tugging on the bridle reins and clucking to him, but Sox never moved or twitched.

"Gail, what happened?" Roz demanded again. "Did you see it? What's wrong with Sox?"

"I don't know," I said. My voice didn't sound like my own. "Maybe a seizure. Maybe heart failure. He kicked Sheila in the head when she came off of him."

Roz sucked in her breath. "He always tries to do that. How's Sheila doing?"

"She's alive," I said.

We both stared at the silent form. Sheila's eyelashes, carefully darkened, lay still against her cheeks. Her blond head wore no protective helmet. I had never noticed anyone but children wearing helmets at Lindee's stable.

"I don't want to move her," I told Roz. "I think the side of her

head that got kicked is facing down. I don't know how bad it is."
I shuddered at the thought of mashed-in skull, bits of brain and
blood.

"No. Better not to move her. All the books say that." A new voice.
Tess, I thought.

Turning my head, I registered that both Nina and Tess stood next
to Roz, Robert and Tom were behind them. Jake was still with Sox.

"Is Lucy here?" I asked. "She could have a look at the horse."

"They left a few minutes ago. Right before it happened." Roz
again.

In the distance came the faint wail of sirens. We all waited as
they drew closer; the flashing lights making the turn into the drive-
way, then pulling up in front of the barn.

"They're going to know the way here by heart pretty soon."
Somebody said it. Nobody laughed.

I stepped away from Sheila as the paramedics approached. Roz
was busy informing one of them about what had happened; the
other two bent over the still form on the ground. I walked up to
the horse.

He was conscious now and had rolled up onto his chest, though
he still blinked and looked dazed. Jake Hanson held the reins and
stared down at him with an expression I couldn't place.

"Let's see if we can get him up," I said.

Jake looked at me. His blond hair frothed off his forehead, his
eyes were still brilliant blue, but somehow the handsome features
looked blurred, as if strained by some strong emotion that he was
holding in check.

"Worthless son of a bitch," he said, looking down at the horse.

"Seems that way," I agreed, "but something's wrong with him. I
want to check his vital signs. Let's see if we can get him up."

One again Jake tugged on the reins and clucked to the horse;
this time Sox grunted and lurched upwards, gaining his feet with
some struggle. He stood there, swaying, head down, but on his
feet.

I stepped toward him.

"Watch yourself," Jake said.

"I will," I agreed, as I touched the gelding's shoulder.

But Sox was too far out of it to pay much attention to me. I checked his pulse and respiration and looked at his gums, all without incident.

"His breathing and heart rate are elevated but not a lot," I said out loud. "His gum color is normal. He didn't have a heart attack. Maybe a seizure." I noticed that Tess, Roz, Nina, and Robert were all watching me and listening. The paramedics were loading Sheila onto a stretcher. "Has he ever done this before?"

Various shakes of the head. Roz spoke. "He tries to jump out from under you, and he kicks out like that, tries to get you as you go by. But he's never collapsed."

"He was out cold, the bastard." Jake's voice.

"All I can think of is a seizure." My eyes found Nina. "Better take him back to the barn and keep an eye on him. I need to make a phone call."

Stepping away from the group, I dug my cell phone out of my back pocket and dialed Jeri's cell; she'd given me this number several years ago, and it had come in useful more than once.

"Jeri Ward, here." She answered on the first ring.

"Jeri, it's Gail. Another person has just had a bad horse wreck here at Lindee's barn. The ambulance is hauling her away now. Sheila Ross—the assistant trainer. I thought you'd want to know."

"I'll be right there." Jeri's voice was sharp, unemotional.

"I'm going home," I said. "I don't know what else I can do here."

"I'll be along later," Jeri said, and ended the call.

I looked around. Nina and Jake were leading Sox in the direction of the barn. The horse walked slowly and he staggered a bit, but he looked like he would be okay.

Roz, Tess, and Robert were in the barnyard, conferring about something as the ambulance departed. Tom Walker was nowhere to be seen.

Nobody seemed to need me at the moment, except Mac and Blue. Turning my back on the barn, I started back down the driveway, heading once again for home.

• • •

"Why me?" I demanded of Blue several hours later, as we sat on the front porch, margarita glasses in hand. Mac toddled around on the old rug beside us, chasing and clutching at the patient dogs, who only licked him and moved away.

"Why did I have to be right there both times? It's not like I hang around the place a lot. What bad thing did I do in a past life to deserve this?" I took a long swallow of my drink.

Blue regarded me impassively; both our eyes swiveled suddenly to Mac, who was wailing. Nothing seemed obviously wrong; Mac lifted his arms in my direction and I picked him up and set him in my lap.

"I don't know, Stormy." Blue seemed to be taking my question more seriously than I had meant it. "It does seem odd."

"I can't quite get it out of my head." I lifted my shirt for Mac. "First Lindee and then Sheila. It just seems too odd to be a complete coincidence."

"But what could cause such unlikely wrecks?" Blue sounded reflective.

"They weren't at all similar, either," I pointed out. "But still. Two women dead in three days at the same stable? Women who were both competent riders."

"Sheila Ross isn't dead yet, we hope," Blue said.

"Not as far as we know," I agreed. I could see a car down by the front gate. "That looks like Jeri. Maybe we'll learn something new."

Jeri drove slowly up the driveway, whether out of respect for my livestock or the potholes, I wasn't sure. We both watched her climb out of the car in her calm, unhurried way, as the dogs barked clamorously from the porch.

"Hush," Blue said reprovingly. "That's enough."

Mac stopped nursing long enough to look up in my face; seeing my smile he returned to suckling—loud, barking dogs were a familiar sound to him.

"Hi, Jeri," I said, as she approached.

"Care for a margarita?" Blue added.

"I'd love to but I can't," Jeri said. "Not on duty."

"Did you just come from the neighbors?" I asked her.

"Yes. And I just got off the phone. Sheila Ross is still alive. She's still in a coma; she's at the hospital. Doctors aren't sure what her prognosis is likely to be. She has a hairline fracture in her skull, but if she comes out of the coma, they think she'll be okay."

"That's good," I said. "But it's a big if." I reflected for a minute on Sheila, who had wanted so badly to be a professional horse trainer, who had obviously worked hard to achieve that goal, and now lay in a coma, victim of the trade she'd pursued so ardently. Victim of Sox, to be precise.

"How was the horse?" I asked.

"The one that threw her?" Jeri asked curiously. "Are you worried about him?"

"Not exactly," I said. "I'm curious. Did anyone tell you that he collapsed and was out cold?"

"Yeah." Jeri consulted her notes. "Nina Harvey and Roz Richards both mentioned that."

"Well, it seems really odd to me. He might have had a seizure, I guess. But if he's perfectly all right at this moment, there's not many explanations that would fit."

Jeri looked at me steadily. "You're suggesting?" she prodded.

"I don't know what I'm suggesting." I waved a hand in frustration, causing Mac to come off my nipple and stare into my face. Without thinking, I tugged my shirt back down and sat him up in my lap; he turned his wide-eyed gaze on Jeri, who gazed back, unblinking.

"I guess I'm just saying what I said to Blue a minute ago," I said, looking over at my husband. "Two very odd horse wrecks in three

days, leaving one professional horsewoman dead and the other out for the count. It seems sort of suspicious to me."

Jeri continued to regard me and Mac. When she spoke, her tone was contemplative. "You were right there for both wrecks, Gail."

"I know. Lucky me."

"In the first case, you thought that Lindee Stone appeared to pass out while on the horse and pulled the animal over backward. In the second case, the horse seems to have passed out after throwing his rider."

We stared at each other a moment.

I nodded. "Yeah. It's occurred to me, too. Maybe somebody gave them something. But what? And why?"

"And what would have a similar effect on a horse and human?"

"Oh, lots of things," I said idly. "Torbugesic, dormosedan, ketamine, rompun." And then I stopped. "But why? And how, exactly?"

"Those are the questions," Jeri agreed. "If we suppose these two wrecks aren't complete accidents, that coincidentally happened close together. By all accounts this horse—" she consulted her notes again "—Sox, was prone to trying to throw people off and kick them going down."

"That's true," I agreed. "But not to collapsing. And I saw Sheila's face. She knew that horse, knew what he'd do. But she looked genuinely frightened, like he was behaving in a way she hadn't expected."

"Okay," Jeri said. "Let's assume, for the purposes of discussion, that these are two attempted homicides. Which brings us back to why and how. If we can answer those two, I've no doubt we'll know who. Which is the bottom line, after all."

"The trouble with starting with who," I said, "is that there were at least a dozen people that I know of with a reason to hate Lindee Stone. Including me."

"People don't normally attempt a murder because their horses are being evicted from a pasture." Jeri smiled at Mac, who had grasped his favorite wooden toy and was clacking it in my face.

"Money and love, right?" I smiled back around the fish toy. "Those are the main motives. And the greatest of these is love."

"So true," Jeri agreed. "If you include in the category of love, jealousy, and the incredible rage some folks seems to feel when a relationship is over."

"I can find more than a couple of suspects for Lindee's murder even if we limit the field to those with the love-gone-bad motive. There's Tom, her present boyfriend, Robert, her ex-boyfriend, and Scott, her ex-husband, just to name three. And all of them were there when she had the wreck. Or shortly before, anyway."

"Yeah. That's a point, isn't it?" Jeri looked reflective.

Mac squawked loudly at being ignored, and Blue removed him neatly from my lap and carried him inside the house.

"But why try to kill Sheila?" Jeri asked, whether of me or the ether, I wasn't sure.

"Because she knew something, maybe? Knew who killed Lindee."

"Uh-huh. That seems the likeliest explanation. If any of this is the least bit plausible. And again, how?"

"Some sort of drug," I suggested.

"And how was this drug administered?"

I shook my head. "Orally?" Shrugging my shoulders, I added, "Pretty hard to give a person a shot without their knowing. As for the horse, it would have been easy to give him a shot."

"Of what?" Jeri asked. "What would cause him to get agitated, convulse, and collapse? Which by all accounts is what he did."

I shook my head again. "Let me think about it. Nothing comes to mind right offhand. You know, we ought to go have a look at Sox. See if he seems one hundred percent normal at this point. It's relevant to this discussion."

"Right," Jeri said and stood up. "Can you come?"

"Can dinner wait?" I called through the open door to Blue. "I need to go look at a horse. Next door."

"No problem." Blue was lying on the floor, watching Mac toddle around, then dragging him over to tickle him, to accompanying squeals of glee.

Thanking heaven for my patient husband, I once again accompanied Jeri out to the car and back to Lindee's place—not for the last time, I was sure.

Chapter 13

LATE AFTERNOON HAD FADED to evening as Jeri and I walked toward Lindee's barn. I could feel the breeze moving in the pine trees, a cold, foggy breath. The marine layer was definitely coming in; I shivered and wished I'd brought a jacket.

Lights were on in the barn, but I didn't see anyone hanging around in the barnyard. Side by side, we walked down the barn aisle to the stall where I remembered Sox was housed.

Sure enough, there he stood, a medium-sized bright bay, about fifteen-one hands, with a white face and over-the-knee white socks, making him technically a paint. At the sight of us peering through the barred window on his door, Sox pinned his ears grumpily and turned away.

"He looks normal," I said. "I'd like to get him out, see if he walks out normally, and what his vital signs are. We'd better find Nina."

This didn't take long. Nina was, predictably enough, in the feed room, stacking hay on her cart. Glancing from me to Jeri, she flipped her mop of curly brown hair out of her eyes and nodded. "Sox, yeah, he seemed okay. I'll get him out if you want."

As we followed her towards Sox's stall, two more figures appeared in the open archway of the barn door. Roz and Charley Richards. They strolled casually towards the three of us; we all met up in front of Sox's stall.

"Gail, good to see you." Charley shook my hand, greeting me with an effusiveness that seemed natural to him. Short and slim, with sandy brown hair and glasses, Charley wasn't my idea of fancy-

looking; however, he sold insurance for a living and was said to be wealthy. Certainly Roz never seemed to lack for money.

I introduced Charley to Jeri, with no explanation, and said that I was here to check on Sox.

Roz smiled graciously at me, including Nina and Jeri in her gaze. "I'm glad you're all here. I've just been to see Sheila."

"How is she?" I asked.

"Still in a coma. Nobody seems to have any idea when or if she'll come out of it."

We were all silent for a moment.

"What I wanted to tell you, and especially you, Nina," Roz said, giving us all that oddly hostess-like smile, "is that it looks like I'll be taking over the stable."

Nina nodded impassively; I gave Roz an inquiring look. Jeri spoke. "Do you mean that you are now the owner?"

"More or less." Roz's eyes flicked to the side and then back to us. "Charley and I lent Scott and Lindee the money for the down payment on this place. They divorced almost immediately after that, and Lindee was barely able to make the payments, let alone pay back the down payment. Now that she's gone, well, Charley talked to Scott, and Scott's happy to turn the place over to us to get out from under what he owes. Scott doesn't want this place, anyway."

Charley flashed a smooth businessman's smile at the three of us.

"My understanding of Lindee Stone's will was that her son inherits her estate," Jeri said mildly.

"He does," Roz agreed sweetly. "But it's held in trust, of course, and his father is the trustee. And after all, what does Jared need with a boarding stable that has a huge mortgage?"

There didn't seem to be much to say to that.

"Will you keep on running it as a training stable?" I asked Roz.

"Yes, I'll be doing the training now," she said firmly.

I looked at her curiously. I had no idea that Roz aspired to being a professional horse trainer. Though it was, in a sense, a glamour profession, it was also a difficult, dangerous job that required many

hours of hard work and didn't pay very well. Not to mention the logistics of running a boarding stable. Roz had always struck me as more of a wealthy dilettante-type horsewoman, well above the more or less blue-collar status of trainer.

"Will you two live here?" I asked them.

"Oh no," Roz laughed and tossed back her auburn mane. "I'll hire a manager to live here and run the place."

"I see." I couldn't help an inward hope that this plan would go bust in a hurry and the property would cease to be a boarding and training barn.

"What I wanted to tell you, Nina, well, ask you really," Roz gave Nina a wide smile, "is would you please, please, keep doing what you're doing until I can get everything organized? I'll pay you whatever Lindee was paying you—four hundred a month and the use of the trailer, wasn't it?"

Nina studied Roz. "Yes," she said at last, "including utilities. And yes, I'll take care of things." It was hard to read Nina's expression, but I had the idea there were some interesting thoughts going on behind that quiet exterior.

Roz gave Nina her gracious smile again. "Thank you so much."

"What about Tom?" I asked.

"Oh, I'll let him know he's got to get out of the house. He's got no claim and he knows it." For a second I saw the edge in her green eyes, then the smile was back in place. "We'd better get home; Charley hasn't had dinner yet. Thank you again." This last to Nina, and with a few more "See you later"s, Roz and Charley departed.

Jeri, Nina, and I exchanged glances. "Well, well, well," I said out loud. "Who would've thunk it?"

"I knew something was up with her," Nina said reflectively. "She and Charley were over here the day Lindee died and I heard them arguing with Lindee. I could tell it was about money and that Lindee owed them some and wasn't about to pay it. Of course," Nina grinned, "Lindee argued with most folks over money. If I had to list out every person she screwed in some deal, the list would

stretch from here to the end of the driveway. And I've only been with her three years."

Jeri and I glanced at each other.

"Let's look at Sox," I said.

"Okay," Jeri agreed. "And then, I think I'll go have a look at the house before Roz Richards takes possession."

Nina took the halter off the peg by the stall door and sighed. "Okay, Sox, you bastard, behave yourself. Don't make me get the shovel." And she slid the stall door open and stepped in with the horse.

Sox scowled at her, but didn't try to kick her; he didn't exactly stick his head in the halter, but he did allow Nina to pull it over his muzzle and buckle it behind his ears without snapping at her. Nina kept her eye on him the whole time, but for a grouchy horse he was pretty mannerly, and she led him out of his stall without a fuss.

I took a brief inventory of his vital signs, which were all normal, and then said to Nina, "Trot him up and down the barn aisle. I want to see how he goes."

Nina did as requested, and Sox moved out with alacrity, looking a good deal more willing and cooperative than I would have expected him to be about this exercise. He was completely sound and moved quite freely, again absolutely normal as far as I could tell.

"He seems one hundred percent," I said to Jeri.

"So is that consistent with him having some kind of stroke or seizure?"

"It's possible, I guess, that he could have had a seizure this afternoon and look this good now, but it isn't likely. I'd expect him still to seem a little dazed and out of it. Maybe still wobble or stagger when he was trotted. That's my experience with other horses, anyway."

"So," said Jeri, and shot a glance at Nina, who was watching us impassively. "Shall we go have a look at the house?"

"Is Tom likely to be there?" I asked Nina, somehow uncomfortable about trespassing on his space, even in the company of righteous officialdom.

"No. He's always out in the evenings. He practices with his band on the weekdays and has gigs on the weekend. He's not there right now." Nina spoke with finality, as if she were absolutely sure of her facts.

Well, it stood to reason, I thought. Nina had been working for and living in the proximity of Lindee Stone for three years. She no doubt knew every detail of every going-on that happened here. I wondered briefly how she would fare working for Roz.

"Thanks, Nina," I said, as she turned Sox back into his stall.

"Yeah, thanks," Jeri agreed.

"I'd better get to feeding." Nina gave us a nonchalant wave and headed back in the direction of the feed room, apparently unconcerned with our reasons for exploring Lindee's home.

I followed Jeri out the barn doorway and up the beaten dirt path that led toward the house. The fog had swept in and long gray wraiths drifted across the dark pines behind the buildings. I shivered again and wished for my coat.

Evening was closing to a chilly dusk, and the house ahead of us—a square, unimaginative gray house in the gray fog with bone white trim and not a light on—was not my idea of a cozy prospect. Let alone it just happened to be a dead woman's home, I didn't in any case like these suburban "ranch" style houses; they seemed cheaply boring, verging on conventionally repulsive.

Jeri knocked perfunctorily on the door and turned the handle, which opened under her hand. It was hard to picture Tom Walker bothering to lock up.

Inside, the house was about what I would have expected—white sheet-rocked walls and ceilings and the ubiquitous yellow-brown "hardwood" floors that seemed to be trendy these days. Most of which weren't really wood. The furniture was as unimaginative as the house: squashy brown fake leather armchair and couch, cof-

fee table and "entertainment center" of some regulation blond wood. The only distinguishing elements were the photos and trophies.

Both coffee table and end tables were covered with glittering silver buckles, trophy saddles rested on saddle racks in all the corners, and the walls were thick with framed photos of Lindee. Lindee accepting said trophy buckles and saddles in formal presentations, Lindee aboard various horses, making a flying turn around a barrel.

I stepped up to the nearest photo and studied it. "Highball," the notation at the bottom said. "First Place, Salinas Rodeo, 1979." I stared. There she was, a much younger Lindee Stone, clearly beating them to death at the big show. A wave of something like sadness washed over me. There she was, at the height of her power, wrapped up in her goals, just like the rest of us, and now she was gone, everything she'd worked for just so much futility.

"Chasing cans," I said out loud.

"What?"

I turned to face Jeri. "Chasing cans," I said, "what cowboys call barrel racing. I guess it struck me as some sort of metaphor for the meaninglessness of life. We chase and chase after whatever it is we think we want—money, power, status—and then, in the end, it doesn't seem to mean very much. Not while you're lying in your grave."

"Agreed," Jeri said. "What's the point? Should we all give up and lie around now, not try to get anything done?"

"No," I said, "I guess that's a point, too. But look," I gestured at the walls of photos. "Do you see even one of her little boy?"

Jeri and I stared at the walls. Every photo showed a barrel racing victory.

"Do you think children are the only important thing in life?" Jeri asked slowly.

"No," I answered, stung. "No, but I think her child should have been at least as important to her as her barrel racing career."

Jeri smiled at me. "As your child has been as important, or more important, to you than your veterinary career."

I smiled back. "You're right. I guess I'm a bit prejudiced. I really don't mean to imply that children are the only important thing in life; it's more a sense of how transitory life is and how unimportant all these victories seem, now that this woman is dead."

"I know what you're saying," Jeri agreed. We both gazed at the trophies and photos. "It all seems pretty hollow." Her eyes snapped back to me. "Do you still think someone killed her, and then tried to kill Sheila Ross?"

"I don't know what I think," I said. I was still staring at the photo of Lindee on Highball. "I just wish she could talk, only for a minute, mind you, and tell us who she thinks might have wanted to kill her."

"By your own account, there's no shortage of suspects," Jeri pointed out, strolling around the room.

I could see her eyes roving, checking the papers on the counter, the half-empty glass of what looked like whisky on the table, the computer on the desk. And suddenly, as kept happening to me these days, I'd had enough.

I wanted out of here, I wanted to go home. I wanted to feel Mac's warm little body in my arms and hear Blue's easy laugh.

"Look, Jeri," I said, "I need to go. Here's the one thing I can tell you. Sox being completely fine, only a couple of hours later, it makes it seem likelier to me that someone gave him something. There's several drugs that might have that effect. Ketamine comes to mind. If it was given in the muscle, it would be very uncomfortable for the horse and might cause him to thrash around like that. And he'd be just fine in a couple of hours. Just like he is."

"What about Lindee?"

"Ketamine would have worked to put her out, too."

"In a shot?"

"More likely in her iced tea," I said reflectively. "It's been used that way before, or so I've heard."

"Yeah," Jeri agreed. "I've heard of that, too. Cases of date rape. Ketamine in the drink, and the girl gets instantly plastered and passes out."

"Something like that. So there's one possible answer for you." I looked around Lindee's empty house and twitched my shoulders. "I need to get back. Will you let me know what Lindee's autopsy shows?"

"I will, indeed. You're my expert consultant on this one, Gail." She smiled again. "I'll be in touch."

"See you," I said. And I was gone.

Chapter 14

MONDAY MORNING PASSED in the steady, uneventful way of time spent at home with one's child. Mac ate and slept and played; I fed him and changed his diapers and watched over him and cuddled him. But I wasn't entirely present. My mind kept drifting down the hill, to Lindee and Sheila and their two wrecks.

As I paced back and forth and stared out the window, I pondered once again the odd truth of motherhood. I loved being a mama, it gave me delight as nothing else had ever done, and yet it was a constant struggle to accept the fact that my whole life was now about taking care of this little person. At the moment I wanted to focus on the peculiar mystery surrounding Lindee's death; I simply didn't want to play "clack the fish" with Mac. And yet…

And yet as I looked down at the round forehead, and the clear, unclouded blue-gray eyes with their long lashes staring happily up into my face, I knew in my heart that Mac was what mattered, now and always. The paradox remained—frustration wedded to pure joy—I simply had to accept that it illustrated the very nature of deep truth.

In the midst of this thought, the telephone rang.

"Autopsy was uneventful." Jeri sounded crisp. I could just picture how neatly pressed her blouse must be. I gave a rueful glance down at my own stained shirt as her voice went on. "Cause of death was blunt-object trauma to the chest, looks like a rib went into her heart, killed her instantly. About what you would expect—that horse landing on top of her was what killed her. Pathologist says no obvious signs she was unconscious at the time, but he's going

to run some blood work. Trouble is, it will take at least two weeks
to get that back. So for now, it remains an accidental death."

"I see," I said. "Will you keep looking into it?"

"Yep. It's pretty much standard procedure. The blood work will
show whether she was drunk, or had taken some sort of drugs,
prescription or otherwise."

"What about Sheila?"

"She's alive. Still in a coma."

"No further word on her prognosis?"

"I haven't talked to the doctors today, but I can tell you one thing
from past experience. The longer she stays in the coma, the worse
the outlook is."

"Yeah. I guess I knew that."

A sudden flurry of barking from the dogs caused me to look
up and out my window. "Hmmm," I said. "There's a white pickup
truck coming up my driveway."

"Recognize it?"

"No." I watched as the truck parked down by the barn and a
man got out. "I recognize the guy, though. Scott Stone."

"Want me to come out?"

"No need. I'm not afraid of Scott." But as I hung up the phone
I wondered at the wisdom of these words. How well did I know
Scott Stone? Didn't he have the best reason of all to kill Lindee? An
ex-wife whom by his own account he hated, who was, in his view,
ruining his son's life as well as costing him personally an enor-
mous amount of money—why wouldn't he want to kill her?

Because you don't just go around bumping people off, my
mind rebutted. Not if you're a normal person.

How in hell would I know how normal Scott Stone was?

I watched him stride up the hill toward the house, slim and neat-
looking, his light brown hair close-cut, his jeans pressed. I really
did not know this man at all. Stepping out on the porch, hold-
ing Mac in my arms, I hushed the dogs and greeted him. "Hi,
Scott."

"Hi, Gail. Sorry to disturb you." Scott flashed his easy smile; I could see his blue eyes sparkle engagingly. Plenty of charm there.

"No problem," I said, not sure about the truth of this. "Come on up." I set Mac down on the battered wool rug we kept on the porch, and sat down myself in one of the two metal chairs, shutting the dogs in the house.

Scott stepped up the stairs and settled himself in the other chair as if he belonged there. "I'd like to talk to you," he said, "it'll just take a few minutes."

"Okay." I watched Mac hoist himself to his feet and waddle rapidly to the porch railing, which was fortunately toddler-proof.

"First of all, I just feel like I owe you an explanation. I was so darn shocked when you and that detective showed up on my doorstep to tell me that Lindee was dead," he smiled at me, "well, I don't think I came off very well."

I murmured something about it being a surprise.

"Yeah, it was a shock. And if I remember right, I pretty much said, good riddance. Which must have sounded pretty nasty."

I gave another inconsequential murmur and watched Mac explore the watering can.

"I just want to explain why I responded that way."

I was about to say that he didn't need to explain, it wasn't really any of my business, but I shut my mouth on the words. Here was another piece of the puzzle. Instead I said. "Uh-huh."

Scott sighed. "I don't think most people have any idea what Lindee put me through. Roz and Charley know. She cheated on me the whole time we were married; I kept trying to turn a blind eye to it, mostly for Jared's sake. Then, shortly after we bought this place next door to you, she asked me to move out, said she'd met the love of her life and she was moving him in."

"And this was Robert Miller?" I ventured. Scott shook his head, an amused smile playing on his lips. "No. Jake Hanson."

"Jake Hanson? You're kidding." I stared at Scott in disbelief. "I've never heard that he split up with Rita, or lived with Lindee."

"He didn't. Apparently he told Lindee he'd leave his wife for her, but when push came to shove, he refused to. I found out that Lindee'd been sleeping with him every time he came out to shoe the horses; they just went back into my bedroom, while my son was in the house. I was pretty pissed off, I can tell you."

Scott met my eyes. "So I left. I filed for divorce. But Jake never moved in. And Lindee took on that Robert character, mostly to make Jake jealous, I think. She certainly kept sleeping with Jake the whole time Robert was living there, which by all accounts made Robert jealous. He used to get drunk and beat Lindee up, at one point she hit him over the head with a shovel; I think I told you about that."

I nodded.

"Anyway, after that she kicked him out and brought home this new guy. The way I heard it, she met this one at a bar one night and invited him home. The guy had nowhere to go so he stayed."

"That's about how I heard it, too." I watched Mac pull the petals off a faded begonia flower.

"That was Lindee for you." Scott shook his head. "The whole time this was going on, she was constantly taking me to court, trying to get more child support out of me, and as far as I can tell, not one penny of that ever went into taking care of Jared. It was all spent on pipe corrals, and fancy tack, and just one more horse she had to have. She owed Roz and Charley a pile of money and they didn't get a cent out of her either. That was Lindee."

I nodded and said, "Uh-huh." As far as I knew, his assessment of his ex was perfectly accurate. It was hard to throttle back the question, "So why the hell did you marry her?" But I managed to do it.

"So," Scott smiled at me again. "I just wanted you to understand why I might have sounded a little bitter."

"I understand," I said.

"Do you think that detective is treating this like a murder investigation?" Scott was watching me intently.

Bingo, I thought. Now I know why he's here. He's worried about Jeri.

"She seems to be a friend of yours," Scott prodded gently.

"We're friends," I agreed. "At the moment it's still an accidental death investigation. That's what Jeri tells me."

"Do they have accidental death investigations?" Scott looked surprised.

"Apparently they do. If the death seems in any way odd. And this one was. You know I was right there?"

Scott nodded

"It looked like Lindee passed out and pulled the horse over. And then Sheila. Did you hear about that?"

"Yes. From Roz and Charley. I didn't know Sheila; Lindee hired her after we split up. But Roz said the horse passed out after throwing her."

"That's right. So that looks a little odd, too."

"I see." Scott was watching me closely. "I take it this detective is looking around to see if she can uncover something that will make these accidents look like attempted murder."

"That's right," I said, not seeing much point in lying about it. "Did Lindee have a heart condition, or epilepsy, do you know?"

Scott shrugged. "Not to my knowledge. I'm sure she didn't while we were married, so if she had something like that it was diagnosed recently."

He stood up. "I'd better get going. I need to go in to the office. But I just wanted to touch base with you."

"How's Jared doing?" I asked.

"All right. Lindee was hell to have for a mother, but she was his mother. I think he's struggling. He doesn't say much, keeps it all inside. Tracy and I are just trying to give him a stable, healthy home, we're not putting any pressure on him to confide in us. I doubt he would anyway. The only way he could cope with having that you-know-what for a mom was to stay shut down tight, so that's what he does. It's his habit."

"Oh," I said. I scooped Mac up, causing him to squawk a protest, unable to resist my urge to cuddle him in the fact of this bitter truth. "I hope things get better for him," I said feebly to Scott, not knowing what else to say.

"Oh, they will." Scott gave me his cheerful smile. "Now that she's gone. Don't tell your friend the detective I said that." And he started down my porch steps. "Thanks, Gail."

"Bye, Scott." I watched him go, thinking that he had just handed me a very strong motive for murdering his ex. But surely he wouldn't have done that if he *had* murdered her. Unless he was cleverer than I supposed. He had, after all given Robert Miller a pretty strong motive for murder, too. A man who had already demonstrated he could be violent, who by all accounts was unhappy with Lindee for ending the relationship; didn't he exactly fit Jeri's description of the type who murders out of jealousy?

And then there was Jake Hanson. Jake, who had apparently had an ongoing affair with Lindee. I wondered what Rita had thought of that or if she had known.

And suddenly I made a snap decision. Carrying Mac toward the truck, I smiled down into his face. "Come on, baby, let's go for a drive. Over to the vet clinic. I need to see a gal about a horse."

Chapter 15

FIFTEEN MINUTES LATER I pulled into the parking lot of Santa Cruz Equine Practice, Mac sound asleep in his car seat beside me. The place looked much as usual. A squat, gray, unimaginative building with roll-up garage-style doors, it had neither a horsey nor a friendly feel, something I'd always hoped to change. However, Jim Leonard, the senior partner in the firm, was just as adverse to spending money on cosmetic flourishes as he was to spending money in general. So far, my desires for renovation had been forestalled.

It wasn't Jim I was looking for today though, it was Lucy. Lucy and Rita. And it looked like my luck was in. A sorrel horse stood in the parking lot next to a shiny silver horse trailer. Rita was holding its head and Lucy was bent over the left front foot.

I glanced down at my sleeping baby, and opened both truck windows so that he'd have plenty of fresh air. Climbing out of the cab, I strolled in the direction of Lucy and Rita, wondering exactly what to say. I couldn't exactly haul off and ask Rita what she knew about Jake's relationship with Lindee.

I stopped when I was a few feet away from the small group gathered around the horse, which included, besides Lucy and Rita, a woman named Laurie Brown, who was no doubt the owner of the sorrel horse. She'd been a veterinary client of our practice for as many years as I'd worked there—almost ten.

Laurie smiled a greeting at me, but kept her attention focused on the horse, as did Lucy and Rita. I watched with one eye and kept the other one on my truck, where my trusting baby slept.

Judging by the way Lucy was digging into the horse's foot, it had a sole abscess. Lucy had no doubt administered a nerve block, so that the foot was absolutely numb and the horse felt no pain, and was now proceeding to open the abscess up so that it could drain.

Sure enough, even as I watched, Lucy raised her head and pointed with the hoof knife. Even from where I stood, I could see the pus spurt out of the hole she'd created in the horse's sole. Laurie Brown nodded her head knowledgeably. She'd owned horses for many years and was more than familiar with sole abscesses. Now that the abscess had burst, and the pressure was relieved, the horse would be immediately better. Laurie and Lucy both smiled.

My eyes shifted to Rita, who stood by the horse's head, keeping a steadying grip on the lead rope. Rita had one hand on the horse's neck, as if to reassure it, but she wasn't really looking at the animal. As far as I could tell, her unfocused gaze was drifting past the horse's head and off into the middle distance. Rita looked lost in her own world.

Given what I'd just heard, I couldn't help but wonder if she was thinking about Jake and whether to get rid of him. Of course, I reminded myself, Rita had been married to Jake for a while, and had always implied that he was one to run around. Perhaps she wasn't particularly bothered by marital infidelities. She was far from the first woman to stick by a promiscuous husband.

Thanking God I wasn't in that category—at least as far as I knew, I thought with an inward grin— I took a step in Rita's direction.

"How's it going?" I said neutrally.

"Oh, fine." Rita's eyes came back from whatever distant place they'd drifted to with a snap, and fixed themselves on my face. "How are you doing, Gail?"

"All right," I said. "I'm a little obsessed at the moment with all the stuff that's gone on next door to me. Did you hear about Sheila?"

"I did," Rita said gravely. "Jake told me. What a shame. I hear she's still in a coma."

"Yeah," I said. "Did you hear about the horse?"

"Jake said it collapsed after it threw her and was out cold. Weird."

Rita's brown eyes bored into mine. "He said you were right there."

"I was," I agreed. "And it was weird. I wanted to ask Lucy a question about it."

At this, Lucy stood up, having wrapped the horse's foot neatly in gauze and a layer of duct tape. "Do you have an EZ boot for him?" she asked Laurie.

"I do indeed." And Laurie produced the plastic hoof-shaped boot from her horse trailer and slipped it over the horse's bandaged foot.

"So, what did you want to ask me?" Lucy looked at me curiously.

I described Sox's odd fit and his subsequent recovery and said, "Do you think that ketamine, injected in the muscle, might have caused that?"

Lucy thought about this a minute. "It's possible, I suppose. It would burn like hell going in; that would be enough to put him in a foul mood. And if it's administered without rompun, or a similar drug, it could cause him to convulse like that."

"My thoughts exactly," I nodded.

"We just did a castration party at the Wilson Ranch in Hollister last week," Lucy went on. "Gave a ketamine and rompun cocktail to maybe twenty or so colts." She smiled. "They're all geldings now."

"Uh-huh," I said. "Any clients asking you for ketamine for their own use?"

"Not that I can think of." Lucy shrugged. "I've heard you can buy it as a street drug. Special K, it's called." She gave me a direct look. "Are the cops supposing that this horse was drugged?"

I spread my hands in an I-don't-know gesture.

"But why?" Lucy sounded confused.

"Maybe in order to cause what actually happened," Rita said matter-of-factly. "Though I don't know who would have wanted to kill Sheila. Lindee, now, that's a different story."

I watched Rita closely, but saw no signs of anxiety. "So you think someone had a reason to kill Lindee?" I asked.

Rita rolled her eyes at me. "Give me a break, Gail. You know as well as I do that half the local horse world had good reasons to murder Lindee Stone. I've got one myself; my husband was screwing around with her."

"He was?" I hadn't expected the subject to come up this easily.

"Damn right he was. 'Course, if you knew Jake, you wouldn't sound so surprised. He's always got to have something on the side."

Laurie and Lucy smiled ruefully. "I know the type," Laurie agreed.

"Just be glad you're not married to one." Rita smiled as she said it; it was hard to read her underlying tone. Handing Laurie the lead rope, she stepped away from the horse and moved to my side.

Laurie led the horse off and Lucy followed her, saying over one shoulder, "Did you want anything else, Gail? I've got to check in with the office, see where I need to be next."

"No, that's it," I affirmed. "I just wanted a second opinion. Thanks."

As Lucy walked away, Rita turned toward me. "I know what you're thinking," she said abruptly. "Why in the world do I stay married to Jake?"

Looking into the challenging, hard brown eyes, I couldn't deny it. "Well, why do you?"

"We've got a lot of history." Rita sighed. "We were both cops in LA, did you know?"

I shook my head, no.

"That's where we met. We both loved horses, both got tired of the stress of our lives, so we got married and moved to northern California. I must have had rocks in my head to think it would work. Jake's ten years younger than me and he was always a lady's man. But he swore he loved me, swore he'd never leave me." Rita laughed.

"So I got a job working here and Jake went to horseshoeing school and started making some money that way, and we get by.

"Anyway, as to why I stay with Jake, I don't know exactly. We have fun, we have a lot in common. His women don't seem to mean much to him." Rita flashed her smile again. "I think I'm still number one."

We both saw Lucy emerging from the clinic; Rita tipped her head in that direction. "I'd better go. Looks like Lucy's in a hurry. Thanks for listening to my troubles."

"Oh, no problem. See ya." I waved to Lucy, who was striding in the direction of the truck, no doubt headed for yet another emergency. I well remembered those days.

Now I was idling toward my own truck to check on a sleeping baby, in no particular hurry at all. Did it feel better, I wondered, or worse? Did I miss being a busy in-charge veterinarian? Maybe a little. But as I stared at Mac's sweet, sleeping face, I knew I didn't miss it half as much as I would have missed him, if I had elected to leave him.

Climbing carefully and quietly into the truck so as not to wake my child, I reflected that I really had chosen the better part. Yes, it wasn't always easy, yes, I did sometimes miss my career, but this, I looked down at Mac, was where I belonged. I didn't envy Lucy— not really.

Chapter 16

WHEN I GOT HOME, Tess Alexander was sitting on my porch, obviously waiting for me. Mac was still sleeping in his car seat, so I parked the truck in the shade, opened the windows, and climbed quietly out. Standing by the truck, I stared somewhat balefully at the figure on my porch. It looked like I was going to have a conversation with Tess, like it or not.

I was being surprised by how annoyed I felt. First Scott Stone and now Tess had felt free to invade my private space without an invitation. I was sure that Tess, like Scott, had something to say or ask about the investigation following Lindee's death, but somehow the annoyance factor seemed much greater when I was faced with Tess.

Leaning on the hood of my pickup I gestured at Tess to come on over. Notwithstanding the fact that I needed to stay close to my sleeping baby, it felt somehow satisfying to resist being coerced into entertaining the woman on my own porch.

As Tess walked determinedly toward me, I gave a moment's thought to why I felt so instinctively adverse to her. She wasn't hostile in the way Lindee Stone had been abrasive, bullying others and perfectly willing to do harm, if only she could gain by it. Tess was just completely caught up in her own story, essentially well meaning, but completely unable to consider the world without herself at the center. Something in her tense attachment to her own viewpoint gave her an unbalanced quality, as if she were constantly on the verge of breaking down. I always felt uncomfortable in her presence.

And she was upon me now, determination writ large in her clenched jaw and rigid stance. "Gail, I need to talk to you." I could have predicted the distraught tone in her voice.

"Here I am," I said, I hoped calmly, trying not to let my resentment show. "If you want to have more than a five-second chat, keep your voice down, my baby's sleeping in the truck."

"Right." Tess lowered her voice, and blinked her wide blue eyes owlishly at me.

She really was a pretty woman, I thought disconnectedly, if only she'd worn a different expression. Unlike Lindee, Sheila, and Roz, who had all sported a certain hard-edged, over-polished, heavily made-up veneer, Tess looked a little fuzzy around the edges, as if her features were not quite fully formed. And yet if you stared at her, as I was doing now, it was hard to find fault with her physically: from her trim figure through her fluffy blond mane to her even featured, blue-eyed face. It was just that hysterical look in the all-too-wide eyes.

Tess looked more nervous than ever; she was obviously aware of my scrutiny and uncomfortable with it. Her eyes darted restlessly from side to side, barely touching on my face.

"So what did you want to talk to me about?" I said at last, taking pity on her discomfort.

"That detective is a friend of yours, right?" Tess didn't give me time to answer. "Does she think Lindee was, you know, murdered?"

"So far they're calling it accidental death." I met her eyes. "I think they're a little suspicious about it, though." I didn't add that I was the one fueling most of the suspicion; why, I wasn't entirely sure.

"I'm just worried about it because of Robert."

"Robert?"

"Yeah. Robert Miller. My boyfriend." Tess smiled at these words.

"Wasn't he Lindee's boyfriend for a while?"

The smile vanished instantly from her face. "That's right," she said bitterly. "He was living with me and when I put Bella in training with Lindee he came out to the barn with me a few times.

Lindee just had to have him. Robert moved in with her, moved his colt into her barn for training; he thought he was in love, but it didn't work out. It took Robert awhile to realize she wasn't the right one for him—"Tess was in full spate now "—but when he did, he was more than ready to come back to me, I can tell you. He realized what he'd lost and he wanted it back."

I studied her curiously. Even at the risk of upsetting her further, I just had to hear her response to the obvious question. "From what I was told, Robert tried awfully hard to get Lindee back after she kicked him out."

"He couldn't accept that it was over," Tess agreed. "Not until recently."

"Not until she was dead, you mean?"

At this, Tess's eyes shot to my face. "That's what I'm afraid they'll think, those cops. They'll think Robert murdered Lindee because he couldn't get over her."

"Ummm, how exactly do you figure Robert might have murdered her?" I asked.

"He didn't murder her," Tess hissed, struggling to keep her voice down. "But it's gone all around the barn that that detective thinks Lindee passed out on the horse and that's what killed her. People are wondering whether she took something herself or somebody gave it to her. I'm afraid they'll suspect Robert."

I had to admit she had a point. Robert appeared to have a pretty good motive for the crime, if indeed it was a crime. Though wasn't it more likely that Lindee had taken something herself, I thought, remembering all the stories about women who had died from diet pills, or some strange combination of recreational and prescription drugs. The only thing that really argued in the other direction was the long list of people who seemed to have a reason to wish Lindee dead.

Like, for instance, the woman in front of me. I stared at Tess, feeling the troubled, edgy aura that emanated from her. With Lindee removed from the scene, she'd been able to get her man back.

"So is Robert living with you now?"

"That's right." Tess smiled again. "He moved back in yesterday."

"And you think this time it will work out?" I thought this was a singularly optimistic hope, especially given what I'd heard of Robert.

"We were made for each other," Tess said simply.

I felt like gagging. Tess was really a remarkably foolish woman.

And then it struck me. This crime, if a crime it was, was a remarkably silly attempt at murder. If Lindee Stone had been given some drug that caused her to pass out, it was only bad luck that had insured that her blackout was fatal. No one could have predicted that at the moment she fell she would just happen to pull half a ton of horseflesh over on top of herself. If she had actually been given something by someone else, and this was a big if, the theoretical murderer had not chosen a very logical way to commit his crime.

His or her crime. I stared at the anxious woman in front of me and could think of no one who fit the picture of an illogical, emotional perpetrator better than her. And here we were, face to face, without another soul around but my sleeping baby.

At that moment, Mac wailed from the truck, causing us both to jump.

"Sorry, Tess, I have to go," I said hastily, moving toward the pickup.

"Right. Will you let me know, well, if there's anything?" Tess finished a bit incoherently.

"Sure," I said, feeling that I wasn't promising much, seeing as I hadn't really understood the question.

And then I was reaching down to Mac, lifting him up and settling him on my shoulder; out of the corner of my eye, I saw Tess start back down my driveway.

Call me before you show up on my doorstep, I felt like yelling after her, but I refrained. The older I got, the less I cared for having my privacy disturbed. And especially by people like Tess, who left me feeling like a cat with its fur rubbed backward.

Why, I wondered, again, was she so disquieting? No ready answer came to mind. But it did make me wonder.

I carried Mac up to the house, changed his pee-soaked diaper, and settled him down with a banana. He'd just taken the first bite when the phone rang.

Joanie Grant's voice was unmistakably excited. "Have you heard?"

"Heard what?" I asked, wondering if we'd been visited by some new disaster.

"That our nasty neighbor is no more."

"Oh. Yeah, I heard about that. In fact, I saw it happen."

"You did? How did it happen?"

I recounted the story; when I was done there was a short silence.

"However it happened, she's gone." I could hear the dismissive shrug in her tone. "No more trouble. Danny and Twister can stay where they are and I don't have to keep looking over my shoulder for fear that she's called the building department."

"Be careful, Joanie," I said, laughing, "they'll suspect you of bumping her off."

"Surely it was an accident?"

"Well, I saw it and it looked very odd. Like she had some kind of fit and passed out, just pulled the horse over on top of her."

"I'd let it alone if I were you," Joanie said sharply. "What good is it going to do to stir up trouble? We're all better off now that she's gone."

"I suppose that's true," I said slowly. "But it's also true that I saw what I saw."

"I'd leave it alone if I were you," Joanie said again. "Let the woman rest peacefully in her grave and be grateful."

"I suppose you heard about Sheila?" I asked her.

"No, who's Sheila?"

"The assistant trainer." And I told that story, too.

"Very strange," Joanie agreed when I was done, sounding not

much interested. It was clear that her one emotion was relief at Lindee's departure.

As we hung up the phone after some cordial good-bye noises, I wondered if she wasn't right. Why in the world was I so keen to see something suspicious in these two apparently unrelated accidents? And why, as Joan had pointed out, would I want to stir up trouble? Like everyone else, I should just be relieved that Lindee was gone.

I watched Mac mush banana into his mouth, more or less—much of it smeared on his face—and wondered. Even if I believed these wrecks were suspicious, what would it avail me or anyone else to look into it? Was pursuing the truth for its own sake enough?

At some level, I supposed, I had to believe that it was. But I was a long way from sure.

Chapter 17

BY THE TIME BLUE CAME HOME, several hours late, due to a rose grower's crisis (climate control in the greenhouse had failed), I'd made up my mind I was going back down to the training barn. I wanted to talk to Nina again. Nina seemed to know everything about everyone, and I had a few questions to ask her.

I'd heated up a pizza for dinner, and Blue seemed quite happy to sit down and partake, while Mac wandered around the table, babbling up at him. I could sense my husband's inward eye-roll at my proposed activity; I felt sure that Blue would have agreed with Joanie's advice. At the same time, I knew he respected my right to pursue my own course, and he had a big appreciation for truth. He would not be totally unsympathetic to the pursuit of this commodity for its own sake.

Unfortunately, I didn't have time to engage in an intriguing discussion on this subject with him right now. Evening was fading to a faintly foggy dusk; I needed to run down to the barn before Nina closed up shop for the night.

I'd fed horses, cats, chickens, and dogs earlier, so all the chores were done. I could see Gunner and Plumber, heads down in their mangers, munching hay as I walked past my own barn and headed down the driveway. The big Mutabilis rosebush planted right where the drive curved was covered with its multi-colored single blossoms, looking like pale, ghostly moths in the dusk.

Another evening I might have appreciated this sight more; tonight my attention was elsewhere, focused on the somewhat sordid details of a possible murder. I barely registered the gibbous

moon rising behind the eucalyptus tree on the eastern ridge. Bright white and almost round—the moon would be full in a day or two, I thought idly.

Then I was out my front gate and headed toward Lindee Stone's horse training establishment. Lights were still on in the barn, I noticed with relief; Nina hadn't shut everything up for the night yet. A truck hitched to a two-horse trailer was in the barnyard; I could see the shapes of horses in the trailer. A single form sat in the cab of the truck. The engine was running—looked like someone was moving their horses out of Lindee's barn. No big surprise there.

I glanced at the truck idly for a minute, and suddenly the motor died. In another second, I heard the click of the driver's-side door opening.

As I watched, a man got out of the truck. Robert Miller— instantly recognizable by his rather blocky, faintly pugnacious stance, somewhat reminiscent of a prizefighter—stared in my direction.

I stared back, wondering what in the world Tess, or for that matter Lindee, had found attractive in such a man. Robert was thick and muscular, sure, if one considered this trait to be an advantage in a male. But the features of his face were coarse and brutish, and the reddish hair was cropped so short he looked as if he'd just been released from the army, or perhaps prison. Even in the gloom, I could tell that the small piggish eyes had a surly cast.

Robert looked around; the barnyard was completely deserted. After a second's hesitation, he moved purposefully toward me. In another moment we stood face to face.

The man's eyes were shaded by his ball cap, but I thought they were sizing me up speculatively. "You're Gail McCarthy, aren't you?" His voice was surprisingly soft, a little hoarse, with a certain underlying force. "The horse vet who lives next door."

"That's right," I said, meeting his eyes. "And you're Robert Miller. The guy who used to live with Lindee."

I have no idea why I said it. What possible purpose could it serve to provoke this man, who by all accounts could be violent? It just seemed to be my instinctive response to him, a verbal version of flipping him off: you won't bully me, you asshole.

It got a response. Robert Miller took a step closer to me; I could feel his whole body bunch itself up, as if every muscle were flexing. "I've heard you're running around with that detective," he said softly, "telling her Lindee's death wasn't an accident. Well, I was there; I saw it, too, and I'm telling you it was an accident. I can't see why you'd want to stir up trouble."

This was pretty much what Joanie Grant had said earlier, but coming from Robert Miller, who was virtually looming over me in the half dark, it carried a completely different freight.

I lifted my chin. "I saw what I saw. If you were there, you saw it, too." Amazingly my voice sounded cool and clear.

Robert moved a fraction closer; I could almost feel his breath on my face. No doubt that he meant to intimidate me.

"I'd quit poking around this place, if I were you." His voice was low and quiet, completely relaxed. Somehow this was more frightening than any amount of shouting. "Lindee's death was an accident. Leave it lie. I mean it.

"You know, I'm a deer hunter," he went on in a conversational tone. This bit of information didn't surprise me.

Robert kept his eyes fixed on my face. "I'm a pretty good shot with that thirty-ought-six that's lying in the rack of my pickup. I got a buck last fall at two hundred yards. That's about the distance from here to your barn."

There was a moment of silence. Robert kept staring at me.

I gathered myself. Did my best to produce a strong tone, rather than a terrified squeak. "Are you threatening me?"

"No ma'am." I could hear his smile, and it made an unpleasant shudder flicker down my spine. "I'm not threatening you. Just telling you that you ought to be careful."

"Right," I said. I'd had enough of this. It was perfectly clear to

me that Robert was the proverbial bad apple; reports of his propensity for violence were no doubt accurate, if not underestimated. He had just moved abruptly to the top of my suspect list.

"I'll be careful," I said. "Real careful. I would recommend you do the same. Right now I've got to find Nina." I wanted away from this man.

But I'd barely started to take a step when I felt his hand on my elbow, gripping me with a frightening strength. "What are you looking for Nina for? More snooping around? I thought I told you to leave this alone. Nobody needs you making trouble."

I glanced wildly around. Every bit of me protested this jerk's dominating hostility; I had the urge to kick him in the balls then and there. However, some vestige of intelligence reminded me that this creep was perfectly capable of seriously hurting me. I needed some sort of help.

And there she was, standing in the lit doorway of the big barn, peering curiously out into the dark barnyard in our direction. Nina.

"Get your hand off of me," I yelled into Robert's face, with all the force I could muster. "Now!"

Robert had seen Nina, too. He dropped his hand, but his face was ugly. "You'll regret that," he whispered.

"Not as much as you'll regret it if you ever mess with me again." My adrenaline was up now. "I am going to tell Detective Jeri Ward every word of this conversation, and if anything, and I mean anything, even disturbs me a little, you will be number one on the suspect list. Do you get that?"

He was already turning away. "Watch yourself," he said over his shoulder.

In another moment Nina was by my side. "Was he bothering you? He's an asshole."

"He sure is," I agreed.

We both watched Robert Miller drive his truck and trailer out of the barnyard.

"I was never happier than the day Lindee kicked him out," Nina

said reflectively. "But he kept hanging around here, messing with his colt, trying to get Lindee's attention. I think she brought Tom home mostly to send Robert a clear message that she wasn't having him back."

The trailer tail lights disappeared down the driveway and Nina smiled. "Looks like we're finally rid of him. And Tess, too. He just loaded up Bella and his own three-year-old and took 'em away. Of course, the two of them owe the barn a bunch of money, which I've no doubt they don't intend to pay, but that's not my problem." She smiled again. "I watched Robert sneak around, loading those horses up and looking over his shoulder to make sure no one was going to catch him, and I didn't say a word. Good riddance. I guess he's taking 'em back to Tess's place, now that he's moved back in with her. What was he hassling you about?"

"He thinks I'm helping Jeri, the detective, investigate Lindee's death, and he doesn't like it. I think he's afraid he'll be suspected."

"Well, he'd make a damn good suspect," Nina said, "if anyone thinks Lindee was murdered. Though I can't imagine why they'd think that."

"It looked like she passed out on the horse," I said. "I guess the question is why. What would cause her to black out?"

"And the cops think somebody gave her something?" Nina chuckled. "More likely she took it herself."

"Really?" I looked at her curiously.

"Oh, Lindee took all kinds of pills. I have no idea what they were. I don't do drugs. I rarely even drink. But I'll share a beer with you if you want to come back to my place."

"Okay," I said. This was just what I'd had in mind, a cozy chat with Nina.

I followed her back down the barn aisle, noting the horses munching hay in their stalls, everyone looking content. Once again we filed out the small side door near the feed room and headed toward Nina's "courtyard." Lights were on in her little trailer, and the small corner looked cozy and welcoming.

I glanced over my shoulder. The pen where Toby lived was empty, the panel hanging open.

"Where's Toby?" I asked anxiously.

"Don't worry." I could hear the smile in Nina's voice. "He's right there." And she pointed.

Sure enough. Toby was just twenty feet away, grazing happily on the rough grass of Lindee's lawn, looking quite content.

"I let him out like this every time I have the chance," Nina said. "I sit here and watch him. He never goes anywhere. And he needs to get out of that pen at least once in a while. Now that Sheila's in the hospital, there's nobody to exercise him."

"Have you heard any more about Sheila?" I asked, as we settled ourselves in the chairs.

Nina produced a beer from a small cooler next to her, poured half of it into her own glass, and handed the bottle to me. "Refrigerator in the trailer doesn't work," she explained. "And the last I heard, Sheila's still in a coma. Roz went by to see her today, apparently."

"Are Roz and Sheila friends?" I asked, this being one of the things I was curious about.

Nina laughed. "Not exactly. More like rivals. But they had a common interest, sort of. Both of 'em were mad as hell at Lindee."

"Why?" I asked.

"It's a long story." Nina took a reflective sip of her beer. "And there's more than one reason. But the short version is they were rivals because they were both sleeping with Jake Hanson. And they both hated Lindee because she was still keeping him on a string."

"Jake?" I almost choked on my beer. "Jake was sleeping with all three of them?"

"Think so." Nina grinned. "Of course, Roz doesn't want it known that she was screwing around with him. I don't think she has any desire to leave Charley. Charley has money."

I nodded. This I knew. Charley Richards did quite well as an

insurance broker, as far as I could tell. Charley and Roz had always seemed relatively wealthy, the times I'd been out to their place on vet calls.

"Sheila, on the other hand," Nina went on, "is single, so she didn't mind letting people know she had a thing with Jake. She was trying pretty hard to detach him from his wife. The only trouble was, Lindee got there first."

"What do you mean?"

"Well, Lindee's been having an off-again, on-again affair with Jake the whole time I've been working here."

"I've heard about that," I admitted.

"Her ex didn't care for it, and neither did her two subsequent boyfriends, but she was always willing to jump in the sack with Jake. I guess when Sheila took up with Jake, he told her it was over with him and Lindee, and maybe it was for a while. But they started back up again. The morning of the day she died, I heard Lindee and Sheila just screaming at each other about Jake."

"Really?"

"Yep." Nina took another sip. "Lindee keeps the ranch computer in the house, all the clients' accounts, board bills, feed bills, you know—all the business stuff is on there. Sheila used to help with the bookwork, and apparently she just decided to check Lindee's personal email and found a note she'd sent to Jake. I guess it made it pretty clear that they were hot and heavy again. Sheila came unglued. I could hear them yelling at each other from here."

"Wow." I took this in, trying to understand how it fit into the big picture. "What in the world do these women see in Jake Hanson?" I asked, almost to myself.

"He's cute." Nina's eyes twinkled. "Sort of like a big puppy dog. Flirts with everyone in a kind of playful, teasing way. Maybe he's really good in bed. I wouldn't know."

"Yeah, but still." I couldn't quite get my mind around it. "He was sleeping with all these gals at once?"

"Yep. At least, I think so. He's always acted perfectly sweet and

charming with every single one of 'em; I've seen him do it, time after time. I guess that's how he made it work."

"Okay, I agree he can be charming and he certainly is handsome, but, my God. Talk about promiscuous." I rolled my eyes.

"Lots of men are like that, though. Look at all the famous guys who've been brought down 'cause of that one little failing." Nina grinned.

I took a long swallow of beer. "Granted."

"So," Nina said, "are you and that detective really trying to figure out if someone murdered Lindee?"

"More or less," I agreed, "though it looks like the person with the best motive was the victim of the second accident."

"I still think it's a lot more likely Lindee took something herself," Nina went on. "After all, having people mad at her for various reasons was business as usual for Lindee. Why would someone try to kill her now?"

"The straw that broke the camel's back," I suggested. "You don't know what sort of drugs Lindee took?"

"Not really. But I've seen her popping various colored pills in her mouth. She got them from Roz."

"Roz?" Once again, I was surprised.

"Definitely Roz. She was always taking something herself. And I've seen her giving them to Lindee. Maybe I should ask for some." Nina grinned.

"I wouldn't if I were you."

"No, I won't. I've read too many stories of women taking diet pills or whatever and having a heart attack or a stroke. I still think that's what happened to Lindee."

"It's a good point." I stood up. "I'd better get going. Thanks for the beer. Do you mind if I tell that detective what you've told me?"

"Go ahead." Nina smiled again. "Want to help me catch Toby?"

"Sure."

And to my surprise, she stood up, walked across the little stretch

of grass to the pony, patted him on the shoulder, and jumped up on his back, all without benefit of halter or bridle.

"Can you ride him like that?"

"Oh sure. I watched the little girl who owned him do it lots of times. You steer him with his mane." And Nina took hold of the long strand of white mane that cascaded from Toby's withers and pulled it to the left.

Obediently the pony's head moved to the left. Nina kicked him and Toby took a few steps in that direction. She tugged backward on his mane, said, "Whoa," and he stopped. "See, it's easy. You can ride him all day like this. Want to try it?" And she hopped off as easily as she'd hopped on.

I was intrigued. I'd never ridden a pony before, or steered a horse by his mane.

"Aren't I too big for him?" I asked.

"Nope. He can carry an adult. He's bred to carry a lot of weight. I wouldn't try to gallop him all day, but someone your size can sure ride him."

I walked up to the pony and patted his shoulder. "Just hop on, huh?" I said to Nina.

"It's easy. Try it."

I jumped up, throwing my body over the pony, belly-down, then swung my right leg across his back. And suddenly, hey presto, I was astride him. Toby grunted, but seemed unfazed.

I took hold of the lock of mane nearest his withers and tugged to the right; at the same time I bumped my legs against his ribs. Toby turned right and moved off.

Nina chuckled. "See?" she said. "It works."

"It does." I laughed, too. "He's fun." I rode Toby in a circle around the lawn and then up to Nina.

"Trot him," she said. "He's got real smooth gaits."

I bumped my heels against Toby's barrel and clucked to him. Obediently he broke into a trot. He was smooth, with a flat, comfortable back, easy to ride bareback. I trotted him in a circle

around the lawn and back to Nina. When I reached her, I jumped off.

"Good boy, Toby," she said. And taking hold of nothing but the long hairs under his chin, she led him into his pen and flipped the loop of baling wire over the panel to close it.

Nina smiled at me as she shut Toby back in. "He's a dandy," she said.

"He sure is. Thanks, Nina. I've got to go." And with a last look at Toby, I trooped down the barn aisle, headed home.

Chapter 18

THE NEXT MORNING AT DAWN, I walked down the hill to feed the horses, cradling a teacup in my hand. Blue was still home, having agreed to go in to work a little late, which was the reason I wasn't cradling a baby instead. I watched the cold, gray fog swirl across the oak trees in eerie ghostlike trails and flipped my sweatshirt hood over my head. Everything looked unreal in the mist, as if I'd suddenly been transported straight from California to a Scottish moor. I could swear I heard the sound of distant bagpipes.

I stopped dead in my tracks. I did hear bagpipes. It wasn't just an auditory figment of my imagination. Faintly, through the wisps of fog, came the melodic droning notes of a piper. For a second I couldn't believe my ears, and then the reality hit me. There was a piper living right next door. Tom Walker.

Except the sound wasn't coming from the direction of Lindee Stone's house. It echoed, appropriately enough, from high on the ridge to the east of me. Just above my little hollow in the hills, to be exact.

And in that split second I made a decision. Leaving the horses to nicker plaintively after me, I took the trail up to the hollow, determined to find Tom Walker.

Even as I hiked through the brush, which left damp marks on my pants and sweatshirt and soaked my sandals, I began to question the wisdom of this course of action. I couldn't see much in the swirling fog; I couldn't even see my house and barn below me. The uncanny, plaintive notes kept calling me onward and upward, but to what? A meeting with a potential murderer?

Somehow I could not picture Tom Walker in the role of murderer; still, it did seem a little unsettling to be stalking him on this solitary fog-swept ridge.

Now I was standing in the hollow; the pipes were playing above me, right on the ridgetop, I thought. I was close enough to think I could pick out the melody—"Scots What Hae," it sounded like. A classic bagpipe tune if ever there was one.

I started up the draw behind the big oak tree; in the shadow of the oak the ground was relatively free of underbrush and provided a fairly easy path to the top of the ridge. On and on the disembodied music wafted above me, the tune faintly reminiscent of "Yankee Doodle." Fog condensed in little droplets on the wisps of hair that trailed out from under my hood. I slipped in the loose duff, stumbled, and spilled some tea. "Damn."

I stopped, hoping the piper hadn't heard me, but the wailing notes went on, morphing suddenly into the somewhat livelier tune of "Scotland the Brave." I smiled; I liked that song. I was pretty sure the piper couldn't hear me scrambling up the slope toward him; bagpipes are a very loud instrument.

I was close now, close enough to guess that the piper was standing on the stump of an old Monterey pine tree that had blown down in a storm several years ago. On a clear day this stump was easily visible from my front porch. Not today. Today the view from the ridgetop was an eerie tapestry of weaving gray and black shadows as the fog crept through the oaks and brush.

Carefully I stepped out from the shelter of a last overhanging branch of the big oak tree. The piper was right in front of me. If I took two steps to the right and peered around an elderberry bush, I would see him.

Abruptly the music changed to "Garryowen." I had to grin. The charge song of Custer's Seventh Cavalry. Here we go.

I stepped around the elderberry bush and looked up. There above me, standing atop the huge, old stump was the dark silhouette of a man in a hooded garment with the hood pulled up, the

distinctive, somewhat animal-like shape of his bagpipes held in front of him, his mouth blowing into the bag while his fingers flickered lightly over the chanter's holes.

Our eyes met as he spotted my moving form; in a breath the pipes were silent. For a second we studied each other. He lowered his pipes.

"Hello, Gail McCarthy." I could hear the smile in his voice.

"Tom Walker, I presume." I said it lightly and stepped forward. "Do you play up here often?"

"No," he said simply. "This is the first time. I'm not often up at dawn, if it comes to that. But no band practice last night. Could you hear me from your house?"

"No. Just when I walked down the hill to feed the horses. How did you get up here?"

"There's a trail. It leads from right behind Lindee's lawn straight up here. It's really a deer trail, so I have to scrabble a bit, but it's not too tough. I've come up here before to enjoy the view and thought what a great place it would be to play the pipes."

"They sounded quite evocative, wailing through the fog. Like being transported to Scotland." I smiled. "I hope you don't mind my tracking you down. I wanted to ask you something."

"About Lindee?"

"Uh, yeah."

"I was afraid of that. Is it you or that detective who's so convinced Lindee's death wasn't an accident?"

"I'm not sure what I think," I said honestly. "At the moment I'm wondering if she passed out due to some sort of self-administered cocktail of drugs. That's what Nina thinks."

"Nina's pretty sharp."

"I thought since you lived with Lindee, you'd know if that was a likely scenario."

"Pretty damn likely, I'd say. A lot more likely than attempted murder."

"So Lindee took pills of some sort?"

The hooded man stared at me through the fog. "Lindee took all sorts of pills," he said. "I have no idea what any of them were. She didn't get them at the drugstore, that much I knew."

"Nina said she got them from Roz." I brushed away the drops of water condensing on the end of my nose.

"Yes, I think she got them from Roz. Who got them from her husband, I believe. Lindee said once that Roz's husband Charley was, I think the words were, well connected. This was when I asked her where she got all the pills."

"I see," I said. My mind was whirling. If Roz and Charley had all sorts of drugs at their disposal, wouldn't it have been easy for either of them to have dropped some sort of lethal dose in Lindee's iced tea? Perhaps if the fall hadn't killed her, the drugs would have. And maybe the blood test could prove this. Roz had seemed quite happy with her takeover of the ranch. But surely she wouldn't have killed Lindee to achieve it? Or would Charley have thought it worthwhile to eliminate Lindee in order to collect on a bad debt?

I had no idea. I didn't really know these people, though they'd been veterinary clients of mine for years. They were just wealthy horse owners, like dozens of other wealthy horse owners I knew; I had no idea what lay under the affluent surface of their lives.

Looking back up at the piper on the ridge, it struck me that Tom Walker had a perfectly good reason to want to kill Lindee himself. After all, he was the one who had currently been living with her, and at least by Nina's reckoning, she'd been cheating on him with Jake Hanson. And there was only Tom's word that he hadn't taken his relationship with Lindee seriously. For all I knew, he'd been downright passionate about her. And here I stood, alone on a ridgetop with the man trying to convince me that Lindee's death hadn't been a murder.

I stared at the hooded form, who continued to watch me quietly, pipes held in front of him. Was it my imagination or did something in his stance shift ever so slightly? Suddenly the fog-drenched

air seemed full of menace; the dark, shrouded figure of the man poised ominously above me, like a creature waiting to spring.

And then he spoke. "I'm getting cold." Quick as a cat, he leapt down from the stump.

I jumped backward so fast that I stumbled and almost fell, spilling what was left of my tea.

"Did I startle you?" Tom Walker was still watching me.

"Yes," I said, a bit breathlessly. "I'd better get back and feed my horses." But I stood frozen, unwilling to turn and start down the hill. Somehow I didn't want to put my back to the man.

After a minute he spoke again. "I'm headed to the house for a cup of coffee. Want to come?"

"No thanks. Horses are waiting."

I stood in my place as he walked by, tromping down the ridge-line, following a faint trail that I could barely see in the fog. As soon as he disappeared, I turned and slithered down the slope to the oak tree and the hollow.

Damn. I did not like it that this man was so close to my property, with an easy route right down to my driveway. The ridgeline marked the property line, so I couldn't really accuse him of trespassing, but still, it made me deeply uneasy.

I picked my way down the steep trail that led from the hollow to my drive; Plumber spotted me as I emerged from the brush and gave an impatient nicker. "Where have you been? You're late with breakfast!" I could almost hear the words.

Smiling, I headed down the hill to the barn to feed the critters, still wondering what to make of Tom Walker. Charming, enigmatic piper or potential murderer? I hadn't a clue.

Chapter 19

BY THE TIME I SAW the dark green sheriff's sedan bumping up my driveway, I was one frustrated mama. For no particular reason, it seemed, some days were just harder than others. Tranquility was hard to come by and my life suddenly seemed endlessly confining, and let's face it, downright boring. It didn't seem to matter that I both recognized this mood and was aware that it would pass; while it had me in its grip, I seemed to wallow in it, pacing up and down the hall, figuratively if not literally wringing my hands and gnashing my teeth.

Mac was playing—noisily—with a wooden train, and I was staring plaintively out the windows, when the car came up the driveway and parked in front of the house, lifting my mood several notches. It was almost noon, and I'd spent the hours since Blue had left for work caring for my child in an almost robotic way. My body was here, but my mind kept drifting off to my eerie encounter with Tom Walker. Not to mention last night's run-in with Robert Miller. I'd put in a call to Jeri, but had only gotten her voice mail, and no return call as yet. The sight of her climbing out of her car was immensely cheering.

I hushed the dogs and shut them in their pen, then handed Mac the coal car that went with his engine, which had fallen behind the couch, and went to open the door.

As usual, I had to overcome my knee-jerk reaction to Jeri's tidy, sleek appearance; my own reflexive, somewhat shame-faced glance at my cargo pants and T-shirt was becoming so repetitive it was starting to bug me. Forcing my chin upward, I attempted a bright smile.

"Hi, Jeri. Come on in." Resisting the impulse to add, "Sorry the house is a mess," I led the way into the main room.

Mac laughed with delight at the sight of a visitor and toddled purposefully in her direction. Perhaps he'd found my somewhat morose company a trial. With visions of sticky little hands creasing the pristine steel blue suit Jeri wore, I scooped him up before he could reach her, to accompanying squeals of protest.

"It's okay," Jeri said, sitting down on one of the wooden chairs by the table. "Let him loose."

"He's liable to mess you up a bit," I said. "Dealing with these little guys is just as messy as working with horses."

"No problem. These are just work clothes."

I refrained from comment and set Mac back down on his feet. He reached Jeri's side in three quick strides, but then hung back, looking up into her face as if taking her measure. Jeri smiled briefly at him and Mac set one small hand very gently on her leg.

I smiled. "Looks as if you've made a connection."

"Kids and animals always like me." Jeri grinned. "I got your message, Gail. What did you want to talk to me about?"

Taking a deep breath, I launched into the saga of yesterday's events, trying not to leave out anything that seemed important and be succinct at the same time. Finishing up with this morning's encounter with Tom Walker, I amended, "So, you see, there's been lots going on, and some of it seems very odd, but I have no idea what, if any of it, is important. Both Robert Miller and Tom Walker sort of creeped me out, and Robert was definitely threatening me, and yet it seems like Sheila is the one who actually had the best motive to murder Lindee. If Nina's right, anyway."

Jeri listened to all this without comment, occasionally drumming her fingers on her leg, to Mac's amusement.

"I guess," I went on reflectively, "in your role of investigating detective, you could look at Lindee's email and see if she sent something to Jake that would prove Nina's story."

Jeri nodded absently, her mind seeming to be elsewhere. "Do

you believe Nina?" she asked, tapping Mac lightly on his head with her forefinger.

Mac giggled. I smiled. "Yeah, I believe Nina. She's just so straightforward and unaffected. And she seems to know everything about everyone down at the barn. Which she would, after having worked for Lindee for so long. I'm sure there's a lot more she could tell if she wanted to."

"Um-hmm." Jeri still seemed to be focused on the middle distance, barely aware of Mac, who was tentatively twisting a fold of her pantleg. When she spoke, it was in a slow, contemplative fashion. "Let's see," she said. "Suppose we leave the whole issue of Sheila Ross out of this and just concentrate on Lindee Stone and her death."

"Have you heard anything about Sheila?" I interjected.

"Still in a coma," Jeri said. "No change so far."

I nodded.

"Anyway," she went on, "let's just focus on Lindee Stone. If, and it's a big if, her death was an attempted homicide, and we assume that the perp gave her some sort of drug which might possibly have killed her if the horse didn't—the blood work may or may not prove this—who exactly was there at the barn in a position to give her something who also had a plausible reason to murder her?"

"Lots of people," I said, shrugging.

"Let's go over 'em."

"Well, Scott Stone, for one," I went on. "He was there. I saw him come to pick up Jared."

"It's interesting you should start with him." Jeri glanced quickly at me and away again. "Since, in essence, he inherits Lindee Stone's estate, as trustee for her son, and he seems to have plenty of motive to do away with her, I ran a routine background check on him. Guess what it showed?"

"I have no idea."

Mac looked at me plaintively; Jeri was no longer paying attention to him and I sensed a wail was coming. Grabbing a bag of

tortilla chips off the counter, I sat him down in his chair and put a pile of chips on the table in front of him.

Jeri watched Mac pick up a chip and nibble on it. "Scott Stone," she said, "has a conviction for date rape. Apparently it happened at a fraternity party when he was eighteen; several other young guys were implicated also. The interesting thing is," and here Jeri looked right at me, "the girl was given a dose of ketamine in her drink."

"Ketamine?"

"That's right. It seemed a slightly odd coincidence, since you had just mentioned that drug to me."

"Yeah." I shook my head. "Wow. Scott Stone has a conviction for date rape. Hard to believe. And they used ketamine."

"Of course," Jeri continued, "from what you've told me, Lindee may have routinely gotten drugs from Roz Richards. If that's true, Roz, or her husband, could have given Lindee something quite powerful, or even lethal, and Lindee simply took the stuff herself."

"And then there's Sheila," I said, "who seems to have been in a shouting match with Lindee that morning over Jake Hanson. Sheila was right there, with both motive and opportunity. For that matter, Jake Hanson was right there. And," it struck me suddenly, "so was his wife, Rita."

"She'd certainly have a motive to murder Lindee," Jeri said, glancing down at her notes. "I don't believe I talked to her."

"I suppose she has a good motive." I watched Mac eat a chip in a ruminative way. "But I know her and I wouldn't be too sure. For one thing, I like her. For another, she seems to know all about Jake's flings and takes 'em in stride."

Jeri shrugged. "I've met lots of criminals I liked," she said. "You'd be surprised how an otherwise decent person can just get pushed over the edge by some little or not-so-little thing, and suddenly find themselves capable of a really violent action."

"I suppose you're right. The fact that I like Rita shouldn't really count in her favor. But let's not forget Robert Miller and Tom Walker, who were both right there and have the classic 'love gone wrong'

motive. Robert seriously seems like someone who might commit a murder. He pretty much threatened to pick me off."

"Yes, Robert Miller." Jeri shook her head. "He's got a string of arrests, mostly domestic violence and barroom fights. I checked into him some. He owes various people money that they would like to collect, as well."

"Does he have a job?" I asked.

"Sometimes." Jeri shrugged. "Apparently, by his account, he's currently day-working as a cowboy at," she looked down at her notes, "the Wilson Ranch in Hollister."

"Wait a minute." I held my hand up. "That name rings a bell. Where have I heard that before?" I pressed my hand against my forehead for a second and then looked up. "From Lucy," I said triumphantly. "She said they did a castration party out at the Wilson Ranch in Hollister last week."

Picking up the remote phone, I dialed Lucy's cell phone.

"Castration party?" Jeri looked quite confused.

"Gelding a bunch of colts all at once," I said. "And guess what? Ketamine, mixed with rompun, is the drug of choice to put the colts out."

I could hear a crackle of static from the phone and then Lucy's voice. "Dr. Conners."

"Hi, Lucy, it's Gail. Have you got a minute?"

"Fire away. We're just driving down the road."

"You said you did a castration party at the Wilson Ranch last week, twenty or so colts, something like that."

"That's right. What about it?"

"Did anyone ask you about the ketamine you used?"

"No, not that I can remember."

"Do you remember a guy named Robert Miller?"

"Nope. Lots of guys there. Nobody I noticed." I could hear the smile in Lucy's voice.

"Did anything odd happen, anything at all?"

There was a second of quiet, then Lucy's voice again, sounding reflective. "It's funny you should mention ketamine, because

I think, I'm not sure, that some of it went missing that day. We were supposed to do twenty colts, so Rita set out twenty vials of ketamine, and then they only had seventeen. Neither of us thought anything about it, but yesterday we had a minor surgery, and when Rita opened the drawer where we both thought we'd left the extra three vials, they were gone. Either one of us might have put them somewhere else, and we just don't remember—but so far we haven't found them."

"So three vials of ketamine might have disappeared that day at the Wilson Ranch."

"Or at some point after that," Lucy said slowly. "They were in plain sight whenever we opened that drawer, which is all the time—you know, it's the top drawer in the rack—where we keep the odds and ends we use a lot. I guess the stuff could have been taken at more or less any call we've done since then. What's this about, Gail?"

"I'm not sure," I said honestly. "I'm helping Detective Jeri Ward look into Lindee Stone's death."

"And she thinks someone may have given the woman ketamine?"

"It's a possibility, like you say. There's no evidence to support it at this point."

"Well, keep me posted. Looks like we're at the next call. Got to go."

"Thanks, Lucy." And I hung up.

"So three vials of ketamine may have disappeared at the ranch where Robert Miller was supposedly working." Jeri whistled softly.

"Or at some call after that. Possibly when Lucy was down at Lindee's," I pointed out.

"What would happen if someone dumped a vial of ketamine into a glass of iced tea and the victim drank it down?"

"I'm not entirely sure," I said. "I think the person would get very out of it, like they were dead drunk. They might pass out. I'm not sure if a horse-sized dose would kill a person." I grinned ruefully. "It's not my area of specialty."

"Hmmm," Jeri said. "And then Robert Miller tells you to stop nosing around. Very interesting."

"And, of course, Tess came snooping around here, trying to find out if you suspected Robert. Silly woman. She's got a perfectly good motive to get rid of Lindee and she's just dumb enough to have tried this method. Not to mention, she was right there. Of course, old Robert was right there, too, and he looks as if he might win some prizes for stupidity."

"There's no shortage of suspects, that's for sure. There does seem to be a shortage of evidence that this was anything but an accident. But I must admit, it looks curiouser and curiouser. Anyone else with a motive?" Jeri drummed her fingers on the table.

"Well, me, I guess. And Joan Grant, the other next-door neighbor. We both wanted rid of Lindee pretty bad. I can't think of anyone else."

"It's plenty to go on with. The only trouble is," and here Jeri rolled her eyes, "I'm afraid this isn't going to get much attention for a while. I've just been called in to an ugly double murder on the West Side; it's bound to keep me tied up for weeks. I had a word with the lieutenant about this case and he just shrugged. I don't think he's very interested, to tell you the truth. So if the blood work doesn't show anything obvious, it looks like this will be ruled an accidental death."

"And the murderer, if there is one, gets away with it." Mac was done with his chips; I set him back down on the floor.

"Maybe," Jeri said. "I'm not going to forget about it. But I doubt I'll have much time to work on it for a while."

"I see," I said. And I did. I wasn't sure if I was disappointed or relieved. As I walked Jeri to the door, I tried to imagine how I would feel, just getting on with my life, disregarding the fact that someone had possibly attempted two murders next door to me. Could I forget about it?

I wasn't sure.

Chapter 20

BY MIDAFTERNOON, I needed to get out. Slipping the sling over my shoulder, I settled Mac into it and headed out the door. I was going somewhere, anywhere. By force of habit, I took the trail up to the hollow, this time in the bright sunshine of a summer afternoon. The fog had cleared and the temperature was seventy-two degrees with a gentle breeze, the nicest weather in the world.

Papery lanterns of rattlesnake grass reached out to brush my legs, sharp-thorned arching canes of wild blackberry snagged at my shirt. I kept one arm protectively over Mac's fluffy little head, using the other to brush branches aside. All the time my eyes scanned the brush, keeping a watch for the shiny lobed leaves of poison oak, checking for whatever creatures were out there, large and small.

I'd met a cougar in these hills once; bobcats and coyotes were common. I wasn't particularly afraid for myself, especially not of the latter two, but Mac, little twenty-pound bite that he was, might look like a tasty morsel.

And then there was just the interest factor. The brush was full of life and I remained fascinated by its denizens, with their mysterious patterns and ways of being. Almost every day I saw something new, whether it was Cooper's hawks mating in the top of a pine tree at dawn, or a bobcat peering at me through the greasewood as I sat in my chair in the hollow.

Grunting a little, I heaved myself and Mac up the last few steep steps and brushed through the screen of ceanothus hiding the hollow. Even as I moved forward, I heard the sound of leaves crunching and branches snapping and registered motion in the

shadow of the big oak tree. I froze, and someone else froze, too. Someone big and tawny brown. Our eyes met for a second; the buck raised his antlered head; I was aware of Mac watching with me. A six-pointer, glossy and strong; his eyes dark, steady, and fathomless, his black nose shiny, his ears up. And then he wheeled and sprang up the hill, flashing the white underside of his tail, disappearing with a great crashing and crackling in the scrub.

Mac and I watched him bound up the slope, both of us riveted. Deer were noisy creatures, I'd found, contrary to their reputation. I could always hear the crunch of leaves and snap of branches when they were about in the brush. The bobcat, on the other hand, was quite silent.

Staring at the place where the buck had disappeared, I realized that he was headed right up to the clearing by the pine snag, the spot where I had found Tom Walker this morning. Turning, I looked down the hill at my garden, wondering just how many roses the critter had devoured. Deer wreaked havoc on my rose vines; most annoying of all, they seemed to prefer the buds over any other portion. Nonetheless, I loved seeing them in the garden and found the sacrifice of flowers a worthwhile trade. What could be lovelier than the vision of wildness I'd just viewed, close up and personal? I'd take my garden with its wildlife and attendant damage over any tidy, tame yard, any day of the week.

Looking down at it now, I caught the flash of light on water from the pond by the porch. The pale yellow Chromatella water lilies floating among their green pads were white dots from here. There was the neat plot of the vegetable garden, surrounded by its rough grapestake fence, draped with climbing roses, nasturtiums, and sweet peas. Just beyond lay the riding arena and the horse corrals, where Gunner and Plumber dozed lazily under an oak tree, swishing their tails. And beyond that—I lifted my chin—lay the boundary fence and Lindee Stone's place. Or what had been Lindee Stone's place. Roz Richards's place now, apparently.

I could see the shapes of horses and people in the barnyard; a

fair number of rigs seemed to be parked in the driveway. People moving their horses out, no doubt, now that Lindee was gone. I wondered how Roz would handle this little problem.

Mac wiggled and squeaked, eager to get down. I lifted him out of the sling and set him on the grass, where he promptly toddled over to some nearby wild oats and began plucking at the seed heads. Watching him with one eye to be sure he didn't put any in his mouth, I kept the other eye on the training barn. I couldn't really identify anyone without binoculars, which I hadn't brought, but my thoughts were racing.

No doubt Roz was there, trying to convince folks to stay and accept her in the role of trainer. Roz, who had provided Lindee with lots of little colored pills, if Nina was to be believed.

And was Nina to be believed? I'd told Jeri I believed her, but that was essentially because I liked her. Just like Rita, however, the fact that I liked an individual didn't necessarily mean that he or she was innocent. Nina had been right on the spot when both wrecks took place; for that matter she was always right on the spot. No one else could have had any more opportunity than she had. But what possible motive could she have? Hating her boss? It just didn't seem like enough of a reason to attempt a murder.

Mac toddled briskly across the hollow in the direction of St. Francis; I turned and hurried after him. He loved to clutch at the two-foot-high concrete statue; I was always afraid he would bring it down on top of himself. Scooping him up, I set him back in the sling and eyed the slope where the buck had disappeared.

"We could go up there," I said out loud. "If I can make it, carrying you."

Mac burbled some sort of reply; I began lugging him up the slope behind the oak tree, following the route I'd taken this morning. Slipping and sliding in the loose oak duff, I struggled to get both myself and Mac up the steep hill without falling.

"Upward, ever upward," I muttered, thinking of "The Man from Snowy River."

After some scrambling, but no tumbles, I achieved the ridgetop, slightly sweaty and puffing hard. Mac looked both interested and pleased; he hadn't objected to the rough climb up the hill, bouncy and bumpy as it must have been for him, and seemed to be regarding our hike as a fine adventure.

For a moment we both gazed out over the brushy slopes. Far down below us lay our home, a little compound of buildings and enclosures. House, barn, chicken coop, vegetable garden, and corrals. It all looked miniature from here, like a cozy little doll's farm. My cedar-shingled house, with its green tin roof and chimney pipe, was a wood elf's hidden dwelling.

And beyond it, looking equally tiny, was the neighboring horse training establishment. I glanced to my left, where a faint trail led off down the ridge. According to Tom Walker, I could follow this path and end up on Lindee's lawn. Hesitantly I began moving in that direction.

It wasn't much of a trail, clearly mainly used by deer and other wildlife. Perhaps the buck I'd seen earlier had come through here. In the way of such trails, many branches had to be ducked under and stepped over, and the brambles and thistles crowded close. Nonetheless, it provided a route, leading, as Tom Walker had said, down the ridgeline.

Ten minutes later I glimpsed my perimeter fence below me as I took step after careful step down a steady but gradual descent. Now I was on the hill behind Lindee's property, indistinguishable from my own slope, being equally steep and thick with the native scrub. Mac squawked a protest as I squashed him, bending nearly double to creep through a tunnel of overarching greasewood bushes. No problem for a deer, even a big buck; less than desirable from a five-foot-seven human's point of view.

The brush opened up suddenly to a small clearing, very nearly level, floored with bracken fern, and walled with ceanothus, coffeeberry, and greasewood. The trail ran right through the middle, leading steadily down the hill. I kept walking, ducking into yet

another tunnel of shrubbery. Mac's eyes were wide and interested as he turned his head from side to side, taking it all in. A plume of scent—both sweet and spicy, the essence of summer—wafted from the creamy yellow flowers of the elderberry bush arching above me. I took a long breath and plowed on.

Peering through the brush as I hiked, I could make out the shapes of Lindee's house and barn growing steadily closer. And in a few more scratchy, brushy minutes, I ducked out from under a coffeeberry shrub to find myself on the back side of the rough patch of lawn beside the gray-and-white house. This was where Nina had turned Toby out to graze the other night.

I could see Nina's trailer across the lawn, and there, in his small pen crowded up against the wall of the barn was the white shape of Toby. I walked in his direction.

When we reached his pen, Toby obligingly thrust his muzzle out for Mac to stroke; I noticed that the pony was very careful merely to snuffle—not nibble—the tiny fingers waving in front of his nose. Someone had taught him good manners, then.

After a minute, I gave Toby a pat good-bye, hefted Mac upward, and headed into the barn. As I turned the corner by the feed shed and started down the aisle, I saw three people about halfway down, standing in what looked like a somewhat confrontational triangle: Nina, facing Charley and Roz Richards. All three turned their heads as I stepped into view. Whatever conversation they were having ceased as I walked towards them. Three sets of surprised-looking eyes followed my progress.

"Why, hello, Gail. To what do we owe the pleasure?" I wasn't sure if it was my imagination that detected a hint of underlying venom in Roz's smiling greeting.

"Mac and I went for a walk," I said airily, "and ended up here. Has anybody heard how Sheila's doing?"

"Still in a coma, poor thing." Roz shook her waving auburn mane. As usual, she looked as glossy as a model in an advertisement, with much black around the eyes and a tight green top that flattered her

figure and coloring. Still, I thought I could detect taut lines of strain in the corners of her mouth. Roz did not look happy to me.

Charley took a step forward. "Gail, we're hearing that there's some sort of investigation going on about Lindee's death and that you're involved. Can you tell us what's happening?" Charley's voice was genial enough, his usual, hail-fellow-well-met insurance salesman's tone in place, but I thought that he, too, looked tense.

Nina was watching me closely. I sincerely wished that I could have eavesdropped on the conversation they'd been having before I walked in.

I smiled at Charley as pleasantly as I could manage, and shifted Mac so that he sat a bit more comfortably on my hip. "I've been friends with Jeri Ward for a long time," I said. "She's looking into Lindee's death, that's true. I don't know a whole lot more." Somehow I did not want to tell these people anything at all.

"The thing is," Charley smiled back, "and I know it's ridiculous, but I've heard rumors that fingers are being pointed at Roz and me, because we're taking over this place. We were just talking to Nina about this. We want it stopped, of course."

Nobody could miss the underlying ice in that last line. I stared at Charley. "You want what stopped?"

"Rumors circulating, gossip about us. It's not good for the barn," Roz chimed in, her own voice somewhat shrill.

"I see what you mean," I said, thinking that probably people were moving their horses away in droves. "But I doubt that will stop Jeri Ward from investigating a problem she thinks needs looking into." I did not mention that Jeri wouldn't be having time for this particular problem. Let them wonder.

"I see." Charley's response was chilly. It was clear to him that I had registered his veiled warning and rebutted with a firm "Forget it"; he did not look pleased. "You know, Gail, this training barn has been a big and lucrative client of your veterinary practice for many years. Just remember, our best interest is your best interest."

"Right," I said. Charley's version of intimidation was a good deal

more civilized than Robert Miller's. "I do hope it works out well for you," I added sweetly.

At this appropriate moment, Mac wailed loudly; he was getting bored. (And I hadn't even pinched him.)

"Got to go," I said. "Mac's getting cranky. Good to see you all. And good luck. Keep me posted on how Sheila's doing." Before anybody could say anything else, I waved cheerily and started down the barn aisle toward the front door.

Just as I reached it, I heard footsteps behind me and turned. It was Nina.

She looked downright nervous and her voice was strained. "Gail, I need to talk to you. Not now," she added quickly, glancing over her shoulder at Charley and Roz, who were out of earshot but quite plainly watching us. "Can you come down and see me this evening? After feeding. They'll be gone then. Maybe eight-thirty, nine o'clock?"

"I think I can," I said slowly.

"Good." And Nina immediately turned away and started back toward her new employers.

I hesitated, then walked out the front door. But even as I carried Mac across the barnyard and down the driveway I wondered about the look in Nina's eyes. Scared. Nina had looked scared. Had Charley and/or Roz said something that had upset her that badly? And what, I wondered, did she want to tell me?

Chapter 21

BLUE DID NOT APPROVE of my going down to talk to Nina. "Gail, I think you're getting carried away with this. Maybe you should have Nina talk to Jeri."

"I doubt she would."

"But this really isn't our business."

I sighed. "Maybe not. But I'm involved, like it or not. I was right there when both wrecks happened. I've thought a lot about what Jeri said, that she wouldn't have time to look into this. And I don't think I'm comfortable with the idea that someone may have attempted two murders right next door. It's just too close."

"We've never been sure that these accidents were attempted murders."

"No. That's true. I'm still not sure. But there are so many odd things about the situation. And Nina definitely looked worried this afternoon."

Had Roz been threatening her, I wondered. Roz had always seemed quite friendly and pleasant in our past encounters, previous to Lindee's demise, that is. I'd never had reason to think ill of her. But a person can smile and smile and be a villain. Wasn't that a quote from Shakespeare? The last remnants of my college classes in literature seemed to be fading fast.

I tried to focus on what Blue was saying. "It almost seems like making trouble, or fueling gossip," he went on.

"That's what Charley said." I sighed again. "I've got nothing to go on here but my own instincts. There's no clear evidence one way or another. The whole thing just feels somehow wrong to me."

"That's what you said from the beginning," Blue agreed. "But do you really have to get further involved? If the cops are willing to leave it alone, why can't you do the same?"

"That's the big question, all right. I've been thinking about almost nothing else all day. It just keeps nagging at my mind. Maybe if I hadn't seen both the wrecks happen, I'd feel differently. But both times I had this sense that there was something odd, something unnatural, going on. It bugs me."

Blue was sitting on the couch, Mac in his lap, and fixed his steady eyes on mine. "Do you really believe these were attempted murders? And if they were, do you believe it's up to you to do something about it, even if the cops won't?"

I shook my head in exasperation. "Put like that, it sounds ridiculous. I don't see myself as some kind of amateur sleuth, or anything. I'm not sure what I believe. No, I'm not convinced they were attempted murders. And no, it's not up to me to solve the mystery. I guess I'm just following where I'm led. Just like in the rest of my life. I'm following my intuition, or sense of truth if you will, as best I can. I can't always see where it's leading me; a lot of times I'm not entirely sure why I'm doing what I'm doing."

Shaking my head again, as if I were brushing away gnats, I smiled at Blue. "I know that didn't make much sense."

Blue regarded me gravely. "I follow what you said. So in this particular case, your intuition is telling you to look into this."

I glanced out into the gathering dark outside the windows and shrugged. "Not exactly. I have this instinct that there's something wrong, something suspicious about these wrecks, and I can't seem to forget about it and drop it, as everybody else seems to think I should. Something just niggles at me. It's more like curiosity than conviction. Don't you want to know the truth?" I demanded.

"The truth?" Blue raised his eyebrows. "The truth is a pretty complicated subject. Do I want to know if someone attempted murder next door? Sure. But do you honestly think you're going to discover who did this and bring them to some kind of justice?"

"I have no idea. Like I said, I'm just following where I'm led. And I think I need to go down and talk to Nina. She looked scared. And I said I would."

"All right," Blue agreed. "I can understand why you'd feel that way. But take the cell phone. Call me if anything seems funny."

"I will," I agreed, shoving this object in my pocket. "But don't worry. I don't think Nina intends me any harm. And even if she did, she could hardly ask me to come down to her place in order to murder me. It'd be like signing her own confession."

"True enough."

"I'd better go," I said. "It's getting late."

"Take care." Blue raised his face for my kiss. I kissed Mac, too, right on the top of his head.

"I'll be back," I said.

And then it was out the door into the moonlit world. Even absorbed as I was in my errand, I stopped and stood stock still after I passed the climbing rose named Jaune Desprez, draped on the last pillar of the porch. In the daylight the loose flowers were creamy yellow with a pink tinge; under the light of the full moon they were silver-white, and the drifting, sweet scent had an unearthly quality. Raising my head, I stared upward at the moon itself, high and hard and round, sailing free above the eucalyptus on the eastern ridge. A full moon, lighting the night sky and illuminating the dark world.

It made for easy walking. I strolled down my driveway in a ghostly parallel of high noon; every pebble, stick, and stump threw a sharp shadow in the clear blue-white light. No trace of fog—the air felt soft and cool against my skin, not chilly, and my lightweight denim jacket seemed perfectly adequate.

Stepping through my front gate, I started down the neighboring driveway toward the training barn. Lights were still on, but I didn't see any people about. I walked in, glanced around, saw no one. Just horses, munching hay inside their stalls. Nina had clearly finished evening feeding; I guessed she was back in her little courtyard.

A small part of my mind registered the soft, scrunching sound of my feet in the raked dirt of the barn aisle as I walked past stall after stall, headed toward the feed room. Inside their small enclosures, horses raised their heads and pricked their ears as I passed. Sox pinned his own ears back grumpily as I looked in his stall.

No Nina in the feed room. I walked out the small side door, looking automatically in the direction of Toby's pen. It was empty, with the gate panel hanging open. My eyes ranged across the lawn and immediately spotted his white shape, bright and ghostly in the moonlight. Toby's head was down; he looked as though he was grazing contentedly. Nina must be in her courtyard.

"Hi, Nina," I called.

Toby glanced my way, but I didn't hear a response.

Nina's little courtyard was empty. No one sitting in the chairs. She must be in her trailer.

"Hi, Nina," I called again, a little more loudly.

Nothing. Crossing the small patio, I smiled at the precariously leaning arbor, with its exuberant crown of grapevines, and yelled Nina's name again as I stepped toward the trailer door.

No answer. As I raised my hand to knock, I glanced sideways through the window. Lights were on inside; surely that was Nina, stretched out on the couch, asleep.

I was about to shout her name again, and then I didn't. Something about her sprawled figure—I stared through the window, narrowing my eyes. Nina didn't look asleep, exactly, her head lolled sideways in an odd way; she looked passed out.

And suddenly every one of my muscles tensed as all my instincts raised a warning. Something is wrong. Inches from Nina's door, my hand reaching for the knob, I froze. Something in the silent air screamed a threat; something, someone was crouched, waiting.

I took a deep breath. In that instant I moved, knowing what to do without thinking. Even as I jumped sideways and backward, I could hear the door slam open. In the same moment that I turned to run, I jerked hard on the nearest of the grapevine's support posts.

The post swung sideways with a screeching crack and the grape-vine and half its arbor tumbled downwards into the courtyard with a crash behind me, as I ran straight out towards the lawn, into the darkness, away from the light. In the periphery of my vision, I registered a figure in the doorway of the trailer, half hidden behind the opening door. I could see what looked like a gun and I ran harder, diving to the ground as the shot rang out, so loud it was deafening.

Oh my God. I didn't know if I was hit or merely winded from the fall. There wasn't time to think. I lunged to my feet to find Toby in front of me, his expression startled, his head up.

I needed to get the hell out of here, into the dark, where I could hide. Hoping that the collapsed vine and timbers would slow the shooter down, I took two steps forward, patted Toby's shoulder, grabbed his mane, and jumped up. I was belly-down on his back as the next shot rang out and Toby spooked sideways; my hand clutching his mane kept me on and I swung my leg over his back and pulled myself upright as he loped across the lawn.

We both seemed to be intact. I drummed my heels against his ribs, wanting away from the lit-up barn, wanting the concealing dark. Toby swung around the big bush at the far side of the lawn and I saw the faint path of the deer trail in the moonlight. Without thinking, I tugged his mane to the right, in the direction of the trail, and kicked him again.

Toby needed no urging; another shot cracked as he lunged into the brush. I ducked low over his neck and twined both hands hard into his mane, putting my face down, letting the pony find the path.

I could feel Toby gather himself and scramble upward; I could also feel the sharp, scraping, scratching branches of the brush swipe at me, as if they would drag me off. Clinging to the pony as he forged ahead, I tried desperately to stay on him.

Using my knees and thighs and heels to squeeze his barrel tight-ly, I clutched Toby's mane and neck with both hands. Moonlight

showed the brush as a tapestry of blacks and silvers whirling wild-
ly past me, lashing at my legs and face. I tried to meld my body
into the pony, tried to find the rhythm in his scrambling run as he
bounded roughly up the slope, out of my control. Hang on, my
mind chanted, hang on.

Up we went, with me like a limpet on Toby's lurching back; he
ducked into a tunnel of brush; I pushed my head down low on his
neck. A branch caught my shoulder hard, dragging me sideways.
Half off, I clung with all my might, even as I could feel my weight
moving too far down his side, past balance. Another jolting stride
and I lost my grip and slid off the galloping pony, landing with a
heavy thud on the ground.

I lay where I fell for a second, gasping, then heaved myself to
my feet. One desperate glance told me where I was. I stood in a
small clearing floored with bracken fern, a clearing I'd walked
through this morning when I'd taken the deer trail from my place
to Lindee's. I could see Toby's white form disappearing into the
brush on the far side; he was still loping, apparently following the
trail, startled out of his usual phlegmatic composure.

I looked over my shoulder. No one in sight. Would they pur-
sue me up here? I had no way of knowing. It suddenly struck me
that falling off Toby had not been a bad move. Toby was large and
white and noisy, easy to spot. All I had to do was crawl off into the
brush in my dark pants and denim jacket and hide. It would be
almost impossible for anyone to find me.

Almost before the thought had formed, I was half crawling, half
scrambling into the brush that ringed the clearing. Using my hands
to part the scratchy branches that fought and tore at me, I searched
for the perfect hiding spot. Even in the chilly moonlight with my
heart pounding in fear, I couldn't escape the memory of huddling
in such "forts" in the brush as a child, playing hide-and-seek with
the neighbors.

The moonshadows were deceiving, but I managed to wiggle
into a clump of greasewood that seemed to form a thick screen

around me. The center had a small, hollow opening that was relatively comfortable. I settled myself where I could peer through the branches and see the trail as it crossed the clearing,

If someone was following me, they would eventually appear amongst the bracken ferns, in full view under the full moon. And I would see them when they could not see me.

Wracking my brain, I tried to tease the briefly glimpsed figure in the doorway of Nina's trailer into someone I recognized, but the picture wouldn't come together. Wearing dark clothes and a ball cap, raising a gun. That was all I could remember seeing.

That and Nina. Shit. Was Nina even alive?

I crouched in the greasewood bush, winded, but, I thought, unhurt. I could hear Toby crashing uphill; he still seemed to be following the trail. And then I heard something else. Branches breaking and snapping below, as someone came up the trail towards me, following the course I'd taken. Pursuing me.

My heart pounded, and I felt half sick. I needed help. Help—of course.

Huddling into the thickest part of my nest, I drew the cell phone out of my pocket. Pushing the automatic dial for "home," I waited. And waited. My heart thumped a frantic tattoo as the crackling of footsteps coming up the path grew louder. The pursuit was getting closer. No ring from the cell phone.

Damn, I thought but didn't say. The phone worked at my house, or at Lindee's house. But it wouldn't work in these little folds of the hills. It didn't work in my hollow, for instance. If I could just get to the top of the ridge it would work.

There wasn't time. Was there anyone nearby who might help if I called out? Blue was too far away; he'd never hear me if he was in the house. Tom Walker was probably out with his band—unless he was the one coming after me. I took a jerky breath as I heard another branch snap. In another few seconds the person scrambling up the hill below me would be in the clearing.

Holding perfectly still, I waited, crouched in the shadow of the

bush, grateful for my dark jacket and pants, my eyes fixed on the spot where the trail entered the fern-covered clearing. In a second, judging by the noise, someone would come into view.

Sure enough, with a scraping and rustling of branches, a head appeared, followed by a torso and legs. But surely—I held in a gasp.

The figure stepped into the clearing and stopped dead. For a second the head swiveled, like a radar dish searching, and then suddenly, to my complete disbelief, the familiar face tilted back as if howling to the full moon, which illuminated every feature.

"Gail! Gail!"

The sound echoed off the hills, and I stifled my jerk of recognition as Rita Hernandez wailed my name like a prayer.

Chapter 22 _____

I DON'T KNOW WHO I'd expected, but it wasn't Rita. My heart hammered hard in shock and dread; I held my breath.

"Gail!" Rita shouted again. "Come back. I need to talk to you. I'm done shooting."

Yeah, right, I thought. I held perfectly still and waited.

"I just need to talk to you. I need to explain." Rita's face turned from side to side, as if she were searching for me, somewhere, anywhere, in the black-and-white moonscape.

"Gail, I know you're out there." Rita's voice was pleading now. "Answer me."

Fat chance, I thought. With that gun in your hand? Do you think I'm crazy?

As if she'd heard my thoughts, Rita said, "I know. You're worried about the gun. I'd throw it away, but I can't. I've got a use for it. But I promise I won't shoot you."

You tried hard enough to shoot me just a few minutes ago, my mind rebutted.

"I know," Rita answered out loud. "I did try to shoot you. It was a mistake. I got so caught up in what was happening that I just couldn't see. I had no business trying to kill you."

Rita stopped talking and stared around some more. The night was silent, or relatively silent, in the way of the brush. Crickets chirped repetitively; I could hear the soft "whoo, whoo" of a great horned owl from the clump of trees on the ridgetop. The noise of Toby's departure had faded away. I had no idea where he'd gone; hopefully he'd end up at my place, drawn by the other horses.

"I think you're out here, Gail." Rita's voice again. "I can feel you, listening."

Stifling my sharp intake of breath, I stared hard at the dark figure. Would she raise the gun? Spray the brush with bullets? I held perfectly still and tried not to breathe.

Let me get out of this, I prayed silently. Let me get home to Mac and Blue. Mac needs me. I'm his mama; I need to be there for him. Please.

I could see Rita scanning the bushes; at some deep inner level, I could feel the brush surrounding us, waiting, aware. In a way I could never explain, I felt its protection, as if this brush country that sheltered me, where I made my home, was taking care of me.

Protect me, I called out silently. Ceanothus, greasewood, manzanita, elderberry, monkey flower, coffeeberry, fern, live oak, madrone, blackberry, sage, poison oak. I chanted the names in my mind like an incantation to these ancient natives, the plants who had been here long before people had come.

Help me, if you would.

For several long seconds we were all a frozen tableau—Rita, the brushland, my huddled, hiding self. And then she spoke.

"I'm going to tell you my story, Gail. I think you're here. And if you're not, well, I'll tell it to these hills.

"I didn't mean to shoot at you, I'm telling you the truth. When I started up this trail after you it got really clear to me that I've gone too far. I'm sorry, Gail. It was never about you. It was that bitch, Lindee.

"I knew Jake had a thing with her, but I never took it too seriously. And then, last Friday—God, it seems forever ago—I checked my email in the morning, like I always do, and there was this note from her telling me I was a bitch for ruining Jake's life, that she and he were meant to be together, they loved each other and why the hell couldn't I let him go, he wanted to be with her.

"So then I checked Jake's email, and sure enough, there was this note from her saying how he'd promised to leave me and move in

with her and why wouldn't he just do it and get it over with, and not to let me ruin their lives.

"You know, Gail," Rita said almost casually, "I could hardly believe it. Me, hanging on to Jake? I've never tried to keep him tied to me. And it just suddenly blew up inside of me, this incredible rage. Pure red-hot fury. All I could think of was, how dared she, the bitch. All that day, at work, I kept thinking of what I could do to her, and suddenly I remembered those extra vials of ketamine, that we hadn't used at the Wilson Ranch. And I just stuck them in my pocket when Lucy wasn't looking.

"I don't think I was really planning to kill her; I just thought I'd ruin her day the way she ruined mine. I have to admit, I had no idea if a horse-sized dose of ketamine might kill her, and I didn't care.

"I knew Jake was shoeing at her barn, so I went out there after work. I saw Lindee's glass of iced tea on the table, and I sat down for a second and just tipped that vial into it. It took half a second—nobody saw me. Jake was talking to that bitch Sheila; I said something to him and then left. That's when I ran into you in the driveway. I never thought that meeting up with you like that was so important, but it turned out to make all the difference."

I took as quiet a breath as I could manage and tried to hold perfectly still, willing her to continue.

"I couldn't believe it when Jake told me later that Lindee was dead," Rita went on. "He just told the story like it had been a big accident; he never looked real upset, never said anything about there being something between them. And the first thing I thought was, yahoo! I couldn't believe I'd gotten so lucky. It sounds terrible, I guess, but I was so glad she was dead, and I never thought that anyone would guess it wasn't purely an accident.

"But it didn't last." I could hear the heaviness in Rita's voice. "I checked Jake's email the next morning and there was one from Sheila, saying that now that Lindee was gone there was nothing to stop them being together but me. And that's where I lost it, Gail.

It was just too much. I couldn't stop thinking about it. I was so damn mad—at Sheila, at the whole situation. I didn't really plan anything, but when Lucy got called out there on Sunday morning, I made sure I had a vial of ketamine in my pocket. And when I heard that Sheila was about to ride Sox, and what a wicked sucker she thought he was, I just slipped back into the barn and gave him some ketamine in the muscle. He didn't like it much, he crashed around a little when I did it, and when I stepped out of the stall, I almost ran into Nina. I guess she was coming to see what all the racket was about. She didn't see the syringe or anything, so I thought it was no big deal.

"And I got lucky again. That horse put Sheila down good. And nobody thought it was anything but an accident. Except you, Gail. You and that damn detective.

"Pretty soon I heard you asking Lucy what ketamine in the muscle would do to a horse, and then you called her up when we were in the truck and she told you that three vials of ketamine had gone missing. You were just getting too close, Gail. I knew you'd talk to Nina and Nina would remember me coming out of the stall. I thought if I could silence Nina it might be all right. And I had one more vial of ketamine left.

"So I made an excuse to visit her and put the ketamine in the beer I brought her. Once she was out, I started to set that trailer on fire. Those little travel trailers burn like kindling. But you showed up, Gail. And I just saw red.

"You again. It seemed like you were determined to catch me. I hid behind the door and vowed I'd make an end of you. But you got away.

"It was only when I was running up this hill, chasing you on that pony, knowing I wouldn't catch you, that it came to me how far I'd gone. I was about to murder Nina, a woman who's done nothing to me. And if I'd shot you, I would have been caught in the end. The gun's registered to me."

I could hear Rita's sigh. "I've gone too far. And I'm not even

sure why, now. I could have made a new life without Jake. I just felt overwhelmed. I can't explain it. But now it's done. It's over. There's one bullet left in this gun."

There was a long moment of quiet, and the owl hooted again.

"There's nothing left to do," Rita went on quietly, and she raised the gun to her temple.

My mind lurched. I started to lunge forward, to try to stop her, and what felt like an invisible cord jerked me back. Stay. I could hear the voice in my head. Do not give her a chance to shoot you. Mac needs you. This is her choice.

Rita stood there, gazing around as if contemplating the moonlit night. "There's not much left to say, I guess." Her voice sounded reflective. "Good-bye."

I should stop her. But even as the thought formed, Rita tilted her head back and pulled the trigger.

Chapter 23

CRACK! THE SHOT SHATTERED the night like glass and Rita's body dropped heavily into the ferns.

Jumping up, I started forward, pushing my way out of the brush, going toward Rita. I could see the blood on her face and head, black as tar in the moonlight; she lay absolutely still.

I stood over her for a second, seeing the gun where it lay by her hand, thinking that I needed to try and get help for her. And Nina. My God, Nina. Would Nina survive the ketamine? Had Rita set the trailer on fire?

I needed to get help, now. And the quickest way was back down the hill. Propelling my shaking legs into a semblance of a run, I staggered and slithered down the trail, ignoring the slaps and stings of thistles and blackberry vines, struggling not to fall.

Panting for breath, I pushed myself through the tunnel of tangled branches, heedless of jabbing sticks. I had to get there. I had to find Nina.

My toe caught on a root, invisible in the mosaic of blue-white light and black shadows, and I stumbled and almost fell headlong. Catching myself with my hands, I shoved my body upright and kept running. Down the hill, toward Lindee's house, toward Nina.

I tried not to think of Rita, her body lying in the clearing where she fell. Tried to keep my mind on Nina, who I might yet help.

Lights ahead of me, the warm yellow light of incandescent bulbs, overwhelming the pale moonlight. Gasping for air, I pushed past a big shrub and found myself on Lindee's lawn. Without thinking, I ran as hard as I could across the rough grass toward Nina's trailer.

It didn't seem to be burning. I couldn't see flames; I couldn't smell smoke. "Nina!" I shouted—and ran.

The wrecked pergola and its grapevine sprawled across the courtyard; as I clambered through the barrier of sticks and vines, I murmured a heartfelt thanks. No doubt that this vine and structure had saved my life. If it had not slowed Rita down and confused her long enough for me to reach Toby...well, I didn't like to think.

I pushed my way past the last leafy arm; I was at the door, hanging ajar; I was inside. Nina still lay on the couch, but to my huge relief she was moving. Moving her head from side to side and moaning.

Reaching her in one stride, I took her hand and said, "Nina, it's Gail."

Nina's eyes stayed closed, and she didn't seem to register my words, but she was still alive.

"Don't worry, Nina. You'll be okay." Hoping this last was true, I dug my cell phone out of my pocket and dialed 911. "I'm getting help," I said calmly. "An ambulance will be here soon."

Mercifully I had a signal and in another second the 911 operator came on. Giving her the relevant info, I asked for an ambulance and said that I would wait. Then I hung up and made two more calls. One to Blue. And one to Jeri Ward.

Chapter 24

THREE LONG HOURS LATER I was back home. Mac lay sleeping quietly in our bed, cuddled into reluctant slumber by Blue. Sitting next to my husband on the couch, with the two dogs lying at my feet, I accepted the short glass of Scotch he handed me, leaned into his shoulder, and began to tell him the story.

It took a while. I sipped Scotch, and answered Blue's questions, and began to feel vaguely more human. I was bruised and sore from my face to my feet; there were burrs in my hair and clothes and scrapes and scratches everywhere on my body—no doubt I would have a bad case of poison oak in the morning—but I was, on the whole, undamaged.

As I reached the part where I'd fallen off the pony, I felt Blue's knee jerk. "So that's where he came from," he said.

"Toby? You found him? Oh my God, I forgot all about him. What happened?"

"You'd been gone awhile, and I'd heard what sounded like firecrackers or shots down below at the neighbor's, and I started to get really worried. Mac was still awake and he was missing you and didn't want me out of his sight, so I carried him outside. I tried calling you on the cell phone, but the call wouldn't go through. I was standing on the porch, wondering what in the hell to do, when I heard the horses start neighing. And another horse was neighing back—from up in the brush.

"I couldn't figure out what was going on, and suddenly this white pony came trotting down the hill from your hollow and loped into the barnyard. I could hear him nickering to Gunner and

Plumber and them nickering and squealing back, so I put Mac in the sling and went down to the barn. The white pony was standing in the hay shed, having a snack; he looked perfectly calm at this point. So I put a rope around his neck, led him into one of the empty corrals, and shut the gate."

"He's there now?"

"That's right," Blue said. "I didn't know what else to do with him. I didn't want him getting out on the road. And I was so damn worried about you. I'd heard what sounded like another shot from up in the brush. I was about to haul Mac down to the neighbor's and look for you, when the phone rang, so I ran back up to the house. Once I'd talked to you and knew you were all right, I went back to trying to settle Mac down and get him to sleep."

"Well, I told you the part about Rita." I shuddered. "It was awful, leading the cops up there to find her body. She looked so…" I searched for the word "…broken."

Blue shook his head. "She tried to kill you. For God's sake, Gail, she tried to kill three other people."

I took another sip of Scotch. "I know. It's probably better this way. But I still feel sad. I can't help it. I liked Rita."

"Will Nina be okay?"

"I think so. I was able to tell the paramedics exactly what had been given to her and one of them looked it up on his computer. He said ketamine has a sort of threshold effect and even if she had quite a lot it would only be a matter of duration, so Nina should be okay when she comes out of it, even though she may have had a horse-sized dose of the stuff. They hauled her off to the hospital, so I assume she'll be looked after."

"So is Jeri Ward taking charge of things now?"

"That's right. She's the reason I was able to get home at all. Otherwise I'd be giving somebody a statement. But I told her what happened and she said I could give them a statement tomorrow. So here I am—in one piece, more or less.

"You know," I took another sip, "it sounds funny, but in a way

I feel guilty, like I'm responsible for Rita killing herself. I can't get it out of my mind, that moment when she lifted the gun. For a second I thought I should try and stop her, and then I decided I needed to save myself. I keep wondering if I did the right thing."

"Gail, get a grip." Blue looked almost angry. "Rita tried to kill three people. You saved Nina's life. What's to feel guilty about? Rita made her own choices, neither you nor anyone else forced her to commit those murders."

"Well," I said reflectively, "the first two weren't exactly murders. Rita had a lot of good luck, or bad luck, however you want to look at it. She could have acted just as she did, and nothing much might have happened. Lindee could have blacked out and come to—same for Sox—and nobody might have come to any harm at all."

"Yes, but she meant harm," Blue pointed out.

"That's true," I agreed. "She was angry. She was lashing out. She meant to hurt them. But you can't say she meant to murder them in any purposeful sense."

"She meant to murder Nina."

"That's right. That's what it all comes down to. I think even Rita realized that. Nina had never done Rita, or anyone else, any harm. She was a good soldier, doing her job. I liked her; I imagine Rita probably liked her, as far as she knew her. When Rita tried to murder Nina, she crossed the line."

"And she tried to shoot you."

"That's right. Rita said as much herself. When she tried to kill Nina, and then me, she'd gone too far. She'd become a murderer, something I don't think she ever meant to be." I thought about it a minute. "In a way, I think Rita was glad I stopped her. Stopped her from becoming a killer. That's the feeling I got, anyway."

Blue put his arm around my shoulders and hugged me gently. "You did the right thing, Gail, don't ever doubt it. You thought something was fishy about these wrecks from the beginning; you followed your instincts and looked into it and you saved Nina's life."

"You're right. And I stopped Rita from purposefully killing any-one—except herself. It isn't exactly a happy ending, but it's damn sure better than if Nina had been killed in a fire."

"Right," said Blue. He hugged me again and teased a burr out of my tangled hair. "Do you want another glass of Scotch or a long hot bath?"

"Both, I guess." And I put my arms around him and kissed him hard on the mouth. "I love you. I'm so glad I got through that and lived to tell the tale. I wouldn't want to miss a moment with you and Mac."

"Me, either," Blue said and kissed me again.

Chapter 25

BLUE STAYED HOME FROM WORK the next morning, while I went down to the sheriff's office to give Jeri my statement. Later that afternoon, after I'd finally managed to cuddle Mac into a nap, I heard the dogs bark and saw a pickup truck pulling up my driveway. I recognized the truck.

My stomach tightened in a nervous clench. It wasn't unexpected really, but I still dreaded this visit.

Shutting the dogs in their pen and telling them to be quiet, I stepped out on the porch and waited. The truck parked in front of the house and Jake Hanson got out and walked in my direction.

I gestured at the two porch chairs and sat down in one of them. Jake nodded, climbed the porch steps, and lowered himself slowly into the other. Neither of us said a word.

For my part, I couldn't help staring at the man. Here sat the cause of Rita's grief and anger, of her eventual suicide. The cause of Lindee's death and Sheila's precarious condition. This man.

Jake still looked tall, blond, blue-eyed, and handsome; even his skin had a golden cast. I didn't know if it was my imagination or the situation that rendered him strangely lifeless, like a mannequin or a wax statue. For all his curly blond hair, wide shoulders, even-featured face, and white smile, Jake looked pathetic—an empty shell of a man.

What had all these women seen in this one thirtyish guy, pretty as he was, to ruin their lives over? I just didn't get it.

Jake sat quietly in his chair and kept his eyes downcast; when he spoke his tone was wooden. "Gail, I don't know what to say."

"Me either."

"Did she say anything about, well, me, before she, you know. Did it?" Jake's eyes were still fixed on the floor of my porch.

"Before she shot herself, you mean?"

"That's right."

I hesitated. Was Jake's ego big enough that he was hoping for some kind of "tell Jake I love him" message? And if so, how much did I want to reveal? That Rita hadn't talked of him at all, except to wonder why she hadn't left him? That she'd raised the gun after a simple "good-bye," which might have been to me or to the world at large. Would this crush him? Did I care?

Tell the truth. The words were clear in my heart. There've been enough lies already. Tell the truth. Let Jake deal with it as he will. It's important.

So I recounted Rita's words in the moonlight as fully and completely as I could remember them, keeping my eyes away from Jake's face, trying to make my voice level, calm, and neutral.

Jake was completely silent as I spoke. I couldn't tell if I was imagining it or not, but his whole body seemed to go slack as he listened, his shoulders caving in, his head slumping lower on his bent neck.

When I came to a stop, we were both silent for a minute. I stared at the brilliantly red rose named Altissimo, draping the end of my porch that overlooked the pond. The single roses glowed, incandescent, fiery, thrilling, amongst the green glossy leaves. Below the vine the water of the pond sparkled like a dark diamond; I could make out the bright orange shapes of goldfish darting between the water lily pads. Deep purple Japanese iris stood sentinel at the far end with ripples around their feet. And placed where she could gaze down into the water was the small concrete staue that always reminded me of a Greek icon; I called her the madonna. Reflected light flickered across her face.

When Jake finally spoke, his words surprised me.

"Is Nina all right?" he asked.

"I think so. I talked to Jeri Ward this morning; she'd just taken Nina's statement. Nina was still in the hospital, and she had the equivalent of a giant hangover, but they say she'll be okay."

"That's good," Jake said heavily. "You went down to Lindee's to see Nina, right? That's what that detective told me. That's how you found her—Rita."

"That's right. Nina said she needed to talk to me. According to Jeri, Nina told her this morning that Roz and Charley had been threatening to throw her out. They thought she was spreading rumors about them. Nina was worried because she didn't have anywhere to go and no money. She wanted to talk to me about what she should do."

"So Nina wasn't going to tell you about seeing Rita come out of that bay bastard's stall."

"No. Jeri said that when she asked her about it, Nina remembered seeing Rita, but she'd never thought anything about it. Nina heard Sox crashing around in his stall and went to check on him; when she saw Rita, she assumed she'd been doing the same thing."

"So Rita didn't need to kill Nina. Nina wasn't even going to blow the whistle on her."

"Not then, I guess. But it probably would have come up in the end. Rita was right about that." As long as I kept asking questions, I thought. In a way, I really had been Rita's nemesis.

"Why?" Jake sounded as miserable as I could imagine a man sounding. "Why did she do this? I never would have left her. She was my wife; I loved her."

"Why did you cheat on her then?" The words just came out of my mouth.

Jake looked down shamefaced, like a little boy caught stealing candy. If this was meant to be cute, it was wasted on me.

"They didn't mean anything to me," he said at last.

"Apparently you told them they did mean something to you."

"I told them what they wanted to hear. It seemed to make them all happy."

"Not in the long term, obviously. Couldn't you see how it would hurt Rita?"

"I thought she understood. I always told her I wouldn't leave her."

I thought of Rita as I had known her, sleek and strong, with that indefinable air of inner power, like a glossy wild cat. Rita had been strong enough to ignore Jake's infidelities all right. The straw that had snapped her was Lindee's blatant nastiness, throwing the whole thing in Rita's face, acting as if Rita were the villain in the piece. And when Rita broke, she hadn't just gone whimpering away. She struck out.

"It was Lindee sending that email. It was too much," I said quietly. "I think Rita had just had enough."

Jake shook his head. "That was Lindee."

I shut my mouth on the words—"Why did you ever have anything to do with that bitch?" After all, the woman was dead.

Instead, I stared steadily at this handsome, blue-eyed man, willing him to go. I wanted nothing to do with Jake Hanson; I was finding that I didn't even feel sorry for him, for all his apparent unhappiness. What I felt was exactly the sentiment Nina had expressed about Lindee—you reap what you sow. Jake had screwed around as if it meant nothing, promising his lovers anything and everything, and was now aghast that his wife had gone off the deep end and then shot herself. It wasn't Jake I felt sorry for; it was Rita.

"I just don't understand how she could do this." Jake was mouthing the words again; I'd had enough.

Cocking my head, I pretended to hear a baby's cry. "I've got to go," I said. "I think my little boy's waking up." And without another word to Jake, I turned and walked back into the house.

Slipping into the bedroom, I slid quietly into the bed next to Mac, curling my body around his sweet, warm, sleeping form. Lying there, I closed my eyes and tried to quiet my breathing and waited. I could hear Jake's footsteps, eventually; I heard his truck

start up and back down my driveway. Taking a deep breath, I buried my face in Mac's neck. Jake was gone.

After several long minutes, I opened my eyes, looking around the safe haven of my bedroom. I took in the small details. A gentle, watery, blue-green light seemed to fill the space in the afternoon, filtering indirectly through the north and east windows. I could see the brush plants peering in, and reflected in the mirror over the antique dresser. On the dresser were photos—of Blue and Mac, and horses and dogs. Next to the dresser, a Navajo blanket in woven shades of coral, blue, and green covered the foot of the bed. And there in the bed next to me, snuggled against my body, lay Mac, his eyelashes a gentle curve against his cheeks, his mouth a pink tinted bow. I watched him breathe and felt a huge rush of gratitude.

I thought of Rita, who was dead, and Nina, who was alive, and watched Mac sleeping peacefully, and was suddenly at peace myself.

Epilogue

I NEVER TOOK TOBY BACK. I left him in his corral at home and kept him; perhaps I stole him, I'm not sure. Nina thinks it's okay, and Roz has never inquired about him; I don't think she even remembers that he exists.

True to my guess, Roz folded the boarding stable in about six months and sold the place. It now belongs to a nice couple who keep a reasonable number of Arabian horses and have a little girl named Rowan.

Jake Hanson left town and never came back. Nina got a job with another horse trainer; I see her from time to time. Sheila Ross eventually came out of her coma and made a complete recovery. And Twister and Danny still graze happily in Joan Grant's pasture. As far as I can tell, no one misses Lindee Stone, except perhaps her son.

I lead Mac around the garden on Toby almost every day and am happy to be here. I think about Rita sometimes and wish things could have turned out differently for her. I still wonder whether my choices led to her death, and ponder sometimes on the nature of choice. Are we led? Do we choose? Both, perhaps—another paradox. Mostly I'm just grateful. Mine is a good life, all in all. And I give thanks for it.

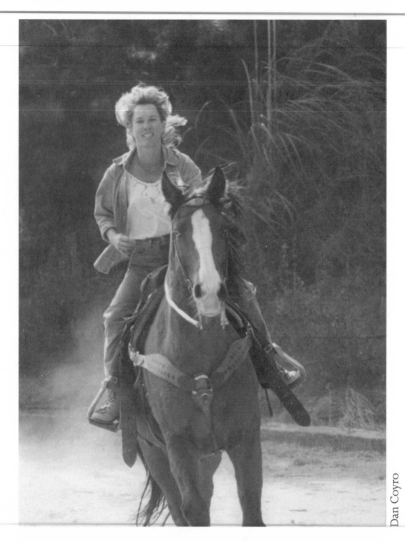

Dan Coyro

ABOUT THE AUTHOR

Laura Crum (pictured on Gunner), a fourth-generation Santa Cruz County resident, has owned and trained horses for over thirty years. She lives and gardens in the hills near California's Monterey Bay with her husband, son, and a large menagerie of horses, dogs, cats, and chickens. She may be e-mailed and visited at www.lauracrum.com.

MORE MYSTERIES
FROM PERSEVERANCE PRESS
🕵 *For the New Golden Age* 🕵

JON L. BREEN
 Eye of God
 ISBN 978-1-880284-89-6

TAFFY CANNON
 ROXANNE PRESCOTT SERIES
 Guns and Roses
 *Agatha and Macavity Award
 nominee, Best Novel*
 ISBN 978-1-880284-34-6

 Blood Matters
 ISBN 978-1-880284-86-5

 Open Season on Lawyers
 ISBN 978-1-880284-51-3

 Paradise Lost
 ISBN 978-1-880284-80-3

LAURA CRUM
 GAIL MCCARTHY SERIES
 Moonblind
 ISBN 978-1-880284-90-2

 Chasing Cans
 ISBN 978-1-880284-94-0

JEANNE M. DAMS
 HILDA JOHANSSON SERIES
 Crimson Snow
 ISBN 978-1-880284-79-7

 Indigo Christmas *(forthcoming)*
 ISBN 978-1-880284-95-7

KATHY LYNN EMERSON
 LADY APPLETON SERIES
 **Face Down Below
 the Banqueting House**
 ISBN 978-1-880284-71-1

 **Face Down Beside
 St. Anne's Well**
 ISBN 978-1-880284-82-7

 Face Down O'er the Border
 ISBN 978-1-880284-91-9

ELAINE FLINN
 MOLLY DOYLE SERIES
 Deadly Vintage
 ISBN 978-1-880284-87-2
 Done to Death *(forthcoming)*
 ISBN 978-1-880284-88-9

HAL GLATZER
 KATY GREEN SERIES
 Too Dead To Swing
 ISBN 978-1-880284-53-7

 A Fugue in Hell's Kitchen
 ISBN 978-1-880284-70-4

 The Last Full Measure
 ISBN 978-1-880284-84-1

PATRICIA GUIVER
 DELILAH DOOLITTLE PET
 DETECTIVE SERIES
 The Beastly Bloodline
 ISBN 978-1-880284-69-8

NANCY BAKER JACOBS
 Flash Point
 ISBN 978-1-880284-56-8

DIANA KILLIAN
 POETIC DEATH SERIES
 Docketful of Poesy
 (forthcoming)
 ISBN 978-1-880284-97-1

JANET LAPIERRE
 PORT SILVA SERIES
 Baby Mine
 ISBN 978-1-880284-32-2

 Keepers
 *Shamus Award nominee,
 Best Paperback Original*
 ISBN 978-1-880284-44-5

 Death Duties
 ISBN 978-1-880284-74-2

 Family Business
 ISBN 978-1-880284-85-8

VALERIE S. MALMONT
TORI MIRACLE SERIES
Death, Bones, and Stately Homes
ISBN 978-1-880284-65-0

DENISE OSBORNE
FENG SHUI SERIES
Evil Intentions
ISBN 978-1-880284-77-3

LEV RAPHAEL
NICK HOFFMAN SERIES
Tropic of Murder
ISBN 978-1-880284-68-1

Hot Rocks
ISBN 978-1-880284-83-4

LORA ROBERTS
BRIDGET MONTROSE SERIES
Another Fine Mess
ISBN 978-1-880284-54-4

SHERLOCK HOLMES SERIES
The Affair of the Incognito Tenant
ISBN 978-1-880284-67-4

REBECCA ROTHENBERG
BOTANICAL SERIES
The Tumbleweed Murders
(completed by Taffy Cannon)
ISBN 978-1-880284-43-8

SHEILA SIMONSON
LATOUCHE COUNTY SERIES
Buffalo Bill's Defunct
(forthcoming)
ISBN 978-1-880284-96-4

SHELLEY SINGER
JAKE SAMSON & ROSIE VICENTE SERIES
Royal Flush
ISBN 978-1-880284-33-9

NANCY TESLER
BIOFEEDBACK SERIES
Slippery Slopes and Other Deadly Things
ISBN 978-1-880284-58-2

PENNY WARNER
CONNOR WESTPHAL SERIES
Blind Side
ISBN 978-1-880284-42-1

Silence Is Golden
ISBN 978-1-880284-66-7

ERIC WRIGHT
JOE BARLEY SERIES
The Kidnapping of Rosie Dawn
Barry Award, Best Paperback Original. Edgar, Ellis, and Anthony Award nominee
ISBN 978-1-880284-40-7

REFERENCE/ MYSTERY WRITING

KATHY LYNN EMERSON
How To Write Killer Historical Mysteries: The Art and Adventure of Sleuthing Through the Past
ISBN 978-1-880284-92-6

CAROLYN WHEAT
How To Write Killer Fiction: The Funhouse of Mystery & the Roller Coaster of Suspense
ISBN 978-1-880284-62-9

Available from your local bookstore or from
Perseverance Press/John Daniel & Co. at (800) 662-8351
or www.danielpublishing.com/perseverance.